IMAGES
of America

EAST BRUNSWICK
THROUGH THE YEARS

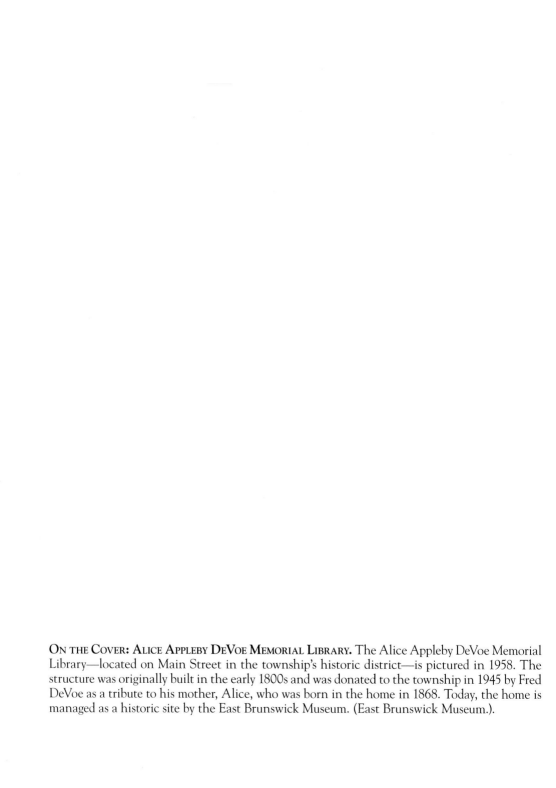

ON THE COVER: ALICE APPLEBY DEVOE MEMORIAL LIBRARY. The Alice Appleby DeVoe Memorial Library—located on Main Street in the township's historic district—is pictured in 1958. The structure was originally built in the early 1800s and was donated to the township in 1945 by Fred DeVoe as a tribute to his mother, Alice, who was born in the home in 1868. Today, the home is managed as a historic site by the East Brunswick Museum. (East Brunswick Museum.).

IMAGES
of America

EAST BRUNSWICK
THROUGH THE YEARS

Mark Nonestied and Ethan Reiss

ARCADIA
PUBLISHING

Published by Arcadia Publishing
Charleston, South Carolina

Printed in the United States of America

Library of Congress Control Number: 2022933596

For all general information, please contact Arcadia Publishing:
Telephone 843-853-2070
Fax 843-853-0044
E-mail sales@arcadiapublishing.com
For customer service and orders:
Toll-Free 1-888-313-2665

Visit us on the Internet at www.arcadiapublishing.com

CONTENTS

ACKNOWLEDGMENTS

There are many people and organizations we wish to thank for their contributions to this book. The East Brunswick Museum—a township treasure—deserves our great appreciation; those who are associated with the museum curate the largest collection of artifacts that tell our story. Unless otherwise noted, the images in this book come from the museum's immense collection. As of the time this book was published in 2022, the museum was under the leadership of a dedicated group of trustees including Joe Coakley, Marc Fafara, George Francy, Estelle Goldsmith, Larry Goldsmith, Christine Grace, Martha Hess, Phyllis Lockwood, Karen Scott, and Verne Whitlock.

We also wish to thank the East Brunswick Historical Society and the work of Ann and Manny Alvarez and Estelle Goldsmith. The following people also provided assistance: East Brunswick mayor Brad Cohen, township business administrator Joseph Criscuolo, Dave Ambrosy, Carmella Textor, Michael Moran, Ann Alvarez, John Emery, Ron Frankosky, Richard Grimm, Bob Bennett, Dorothy and Kathy Baird, Jerry Bergen, Susan Kramer, Jon Gaertner, Trisha Connolly Van Dam, Judy Borman, Bob Gatarz, Jim Selnow, Craig Zavetz, Don Sauvigne, Viriginia Brewster, Louis and Joy Goldstein, Rosalie Littlefield, Alex Todoroff, Robert Wasilewski, Denise DeAngelo Gonzalez, and the New Jersey State Museum. We especially want to thank the hardworking staff members at the *Home News* and *Sentinel* newspapers, for without their work, we could not have been able to capture these rare moments in time that we can now present to our readers.

We also wish to recognize folks who have contributed to East Brunswick's history that are no longer with us. Alberta Yuhas, Grace Auer, William Kreamer, Rose Sakel, and Carmen Logue were all great advocates and would be proud to know their work continues on.

The folks at Arcadia Publishing provided much guidance, and we thank them for their editorial suggestions.

The authors also wish to thank our respective families for the support they have given over the years—Karen, Madeline, and Charles Nonestied, and George, Rosemary, and Todd Nonestied, as well as Richard and Paula Kaplan-Reiss, Gabriel and Elijah Reiss, and Anita Kaplan.

We thank the many people who have come forward to help with this book, and any omissions or errors are our own.

INTRODUCTION

East Brunswick through the Years is a journey through history using images from both public and private collections. It looks at the evolution of the town and the people who have called East Brunswick home. The book is laid out in a chronological format, and each chapter is illustrated with period images as well as recent photographs that help tell our story. The beginning of each chapter also contains a short history of the subject we are covering in that specific chapter.

East Brunswick has a rich and diverse history dating back to the earliest period of settlement in the area in the late 1600s. During that time, English, Scotch-Irish, Dutch, Native Americans, and African Americans lived in what would become East Brunswick. Chapter one—"The Early Years"—focuses on this period and begins with a look at Native American history through photographs of artifacts found throughout the township. One of the earliest maps of the area, a 1685 survey of the "Rariton [*sic*] River," is also examined, and the authors overlay modern-day East Brunswick landmarks to put the map in context.

Chapter two—"A Revolutionary History"—examines the turmoil when East Brunswick was part of the "Crossroads of the American Revolution" during the time when the independence of the United States was forged. The 1800s are covered in chapter three, with an emphasis on the years between 1860 (when the township was created) and 1899. During this period, a farm-to-market economy was developed that would define the East Brunswick community for much of its existence. Photographs from this period are scarce, and the authors use these rare images as well as period paintings, images from the more recent past, and photographs of artifacts to tell a story.

The early 1900s kicked off a new century, and chapter four looks at East Brunswick from 1900 through the 1940s. New immigrant groups began to arrive, with many coming from Eastern Europe. World War I, the 1918 influenza pandemic, and the Great Depression of the 1930s all impacted East Brunswick. This was also when photography developed on a larger scale, and as a result, we are able to include more period images, often of everyday scenes.

The postwar years continued to see a melding of cultural groups within our community. These were also the decades of greatest change, as the community was transformed from a rural landscape into suburbia. This transformation is covered in chapter five, and the authors have placed a strong emphasis on this era; chapter five contains the largest number of photographs in the book. Chapter six—"The Recent Past"—continues the story of change with additional images from the 1970s through the early 1990s.

The opportunity to compare and contrast the evolution of our township can be seen in chapter seven—"Past and Present." Images in this chapter are arranged to show the viewer the same settings through time. The eighth and final chapter is a photographic essay of sorts that looks at East Brunswick today. It creates a unique snapshot of our community, freezing it in a moment of time and preserving it for prosperity.

One

THE EARLY YEARS

East Brunswick Township was incorporated in 1860, but settlement of the area dates back even further. The Lenape, New Jersey's native people, lived for thousands of years in what would become East Brunswick. Stone implements and ceramic artifacts associated with the Lenape have been found in the area over the years. These are tangible materials that give testament to the first people to call this land home.

The first Europeans began to arrive in the last quarter of the 1600s. They valued fertile land, raw material, and accessibility to water-based transportation routes. These early settlers lived in areas along the watercourses of the Raritan River, Lawrence Brook, and South River, where goods could be carried to local markets by sailing vessels faster than over land routes. Some of the items brought to market during this period included wood, farm produce, and pottery. In exchange, manufactured goods were transported back along these waterways. Glassware and ceramics from England, the Netherlands, and Germany, as well as Chinese porcelain, have been found in archaeological sites throughout the region. While these early European settlers may have lived in a rural environment, they were never far from the markets of the world.

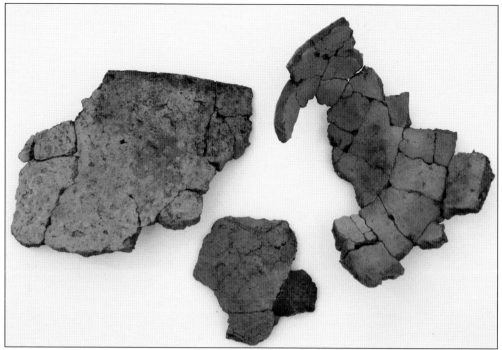

NATIVE AMERICAN ARTIFACTS. The Lenape lived for thousands of years within the area that would later become known as East Brunswick Township. Over the years, artifacts have been found that provide evidence of their early existence. In addition to stone implements, pottery pieces have been recovered from sites in East Brunswick.

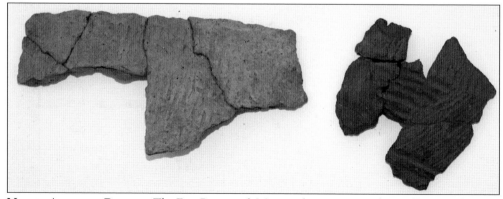

NATIVE AMERICAN POTTERY. The East Brunswick Museum has an outstanding collection of Native American pottery. The clay used to make pottery was hand-sculpted and then made durable by placing it over an open fire. Decorative elements were carved into the body or lip of the pieces.

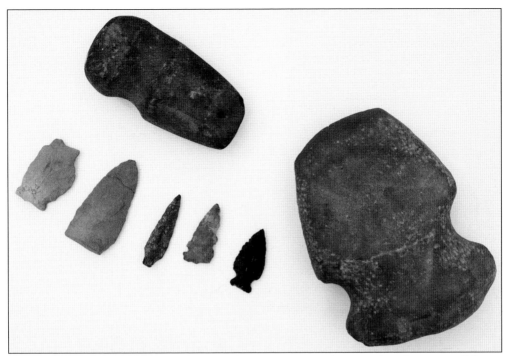

NATIVE AMERICAN STONE TOOLS. Stone implements are some the most abundant types of Native American artifacts found in East Brunswick. Their shape and size often speak to how they were used. Over the years, stone spear points, arrowheads, and ax heads have been uncovered in the township. The examples shown here are on display at the East Brunswick Museum.

EARLY FIREPLACE. Homes from the 1700s were built with fireplaces that were used for both cooking and heating. This image shows the fireplace inside Lilac Hill, a historic house that was demolished in the 1970s. It was located near interchange 9 of the New Jersey Turnpike. The East Brunswick Historical Society was formed as a result of the destruction of Lilac Hill, and much work has taken place since then to preserve and interpret the township's history. (Ann and Manny Alvarez.)

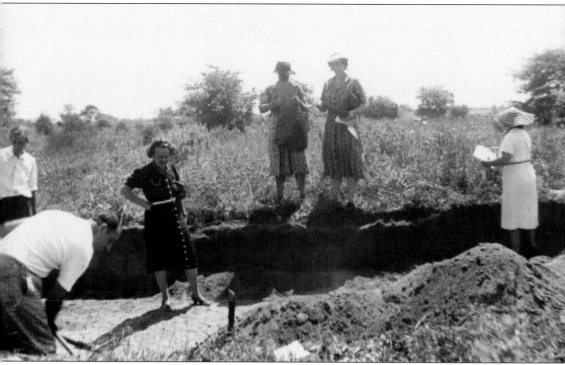

Dorothy Cross on Bennett's Island, Late 1930s. Archeologists have located Lenape campgrounds within East Brunswick. One of the largest was located on Bennett's Island, a parcel of land along the Raritan River and Lawrence Brook. This image shows New Jersey state archeologist Dorothy Cross and her team excavating on the island. Cross was the supervisor for the Indian Sites Survey for New Jersey, a project overseen by the Works Projects Administration during the 1930s. Most of this site has been lost and is now part of Edgeboro Landfill. (New Jersey State Museum.)

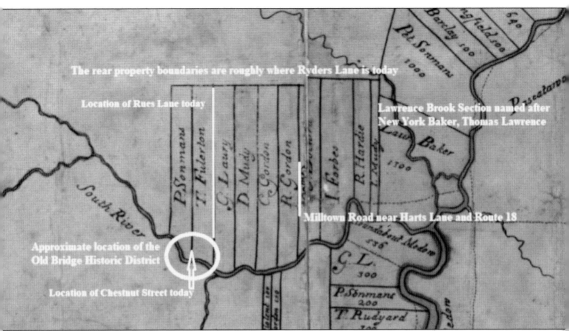

The rear property boundaries are roughly where Ryders Lane is today

Location of Rues Lane today

Lawrence Brook Section named after New York Baker, Thomas Lawrence

Approximate location of the Old Bridge Historic District

Milltown Road near Harts Lane and Route 18

Location of Chestnut Street today

DETAIL FROM "A MAP OF THE RARITON [SIC] RIVER, MILLSTONE RIVER, SOUTH RIVER" BY JOHN REID, 1685. One of the earliest maps of central New Jersey was completed in 1685 by surveyor John Reid. The map shows large parcels of properties laid out along the watercourses. For East Brunswick, much of the earliest settlement occurred along the Raritan River and the South River. The Fulerton and Sonmans Tract, noted in the image, is in the vicinity of today's Old Bridge Historic District in the southeast corner of East Brunswick. Several roads were later laid out over these early property lines. (Library of Congress, with notations added by Mark Nonestied.)

BURIAL GROUND ALONG RIVER ROAD. In the 1970s, several graves were found along River Road near Sunset Boulevard. These were attributed to enslaved people from the Barkelew family. The remains were disinterred and reburied in Chestnut Hill Cemetery.

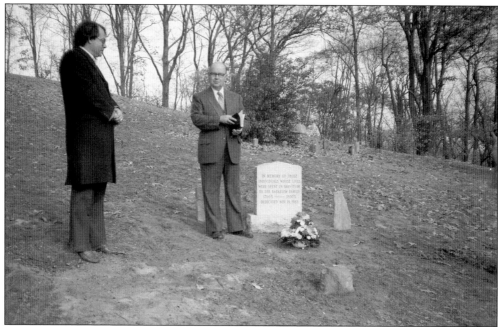

REINTERRED BURIAL SITE AT CHESTNUT HILL CEMETERY. The remains found along River Road in the 1970s were reburied in 1983 at Chestnut Hill Cemetery, and a new granite marker was erected to honor those buried. Two rough fieldstone markers from the original cemetery were reset on each side of the modern marker. This image shows the reburial dedication.

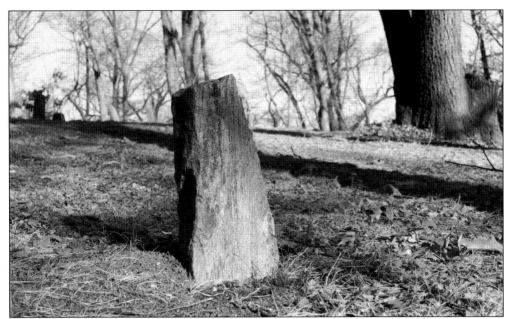

ORIGINAL FIELDSTONE MARKER. This is one of the two original markers from the burial ground discovered along River Road in the 1970s. It was reset in Chestnut Hill Cemetery in 1983, when the graves were relocated. This is a simple piece of fieldstone with no inscription, but it speaks volumes of the enslaved person whose grave it once marked. (Photograph by Mark Nonestied.)

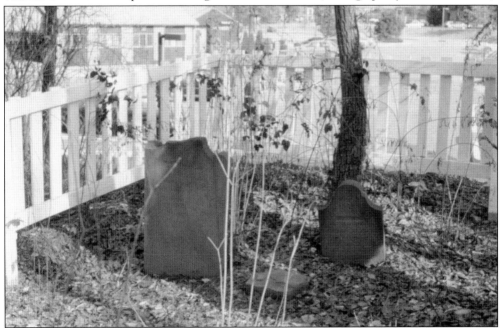

CHEESMAN CEMETERY. Burying the dead on family farms was a common practice in the 1700s and early 1800s. Three family burial grounds survive today in East Brunswick, including the Cheesman Cemetery. The cemetery is located along Brier Hill Court and contains several surviving headstones that are over 200 years old. This photograph of the burial ground was taken in the late 1980s. (Mark Nonestied.)

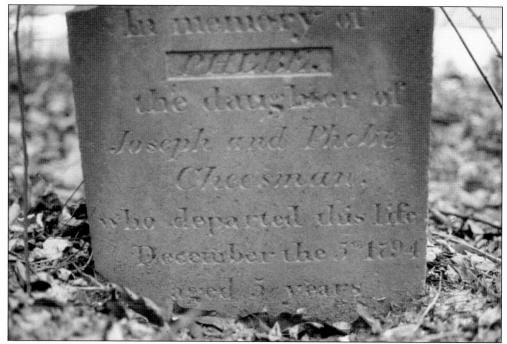

DETAIL OF PHEBE CHEESMAN MARKER. The oldest grave marker in the Cheesman Cemetery is for Phebe Cheesman, who died in 1794. Phebe was the five-year-old daughter of Joseph and Phebe Cheesman. Her marker was carved from New Jersey brown sandstone—a common material used for grave markers during the 1700s and early 1800s. This photograph was taken in the late 1980s. (Mark Nonestied.)

STURKIE HOUSE, APRIL 1978. This photograph shows a home at 103 Fern Road. At this time, it was owned by the Sturkie family and was built in several sections, with the earliest portion dating to the mid-1700s. The property was later purchased by a developer, and the home was demolished.

HERBERT FARMHOUSE, DECEMBER 1991. The Herbert House originally stood at the corner of Rues Lane and Milltown Road. It was once the home of Russel Herbert and his family. Russel was involved with civic endeavors in the township as well as the Middlesex County Fair. The home was built in the early 1800s and demolished in the 1990s. A Wawa convenience store was built on the property.

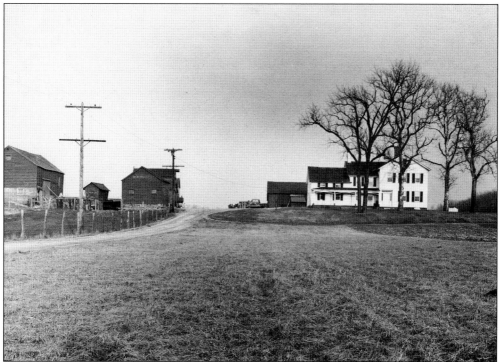

CLARK FARM, C. 1949. The Clark Farm is located on Dunhams Corner Road near the entrance to Heavenly Farms Park. The farmhouse is one of the earliest surviving farm structures in East Brunswick and dates to the 1700s.

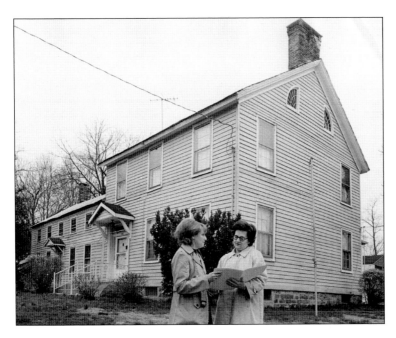

COLE HOUSE, APRIL 1975. The Cole House is located on the corner of Old Bridge Turnpike and Main Street in the township's historic district. The smaller one-and-a-half-story section of the home was built in the 1700s. The house was enlarged in the early 1800s, when it was owned by Obadiah Herbert, a prominent resident of that section of town. The home is now owned by Barry and Jeanne Cole.

EGGERS HOUSE, MAY 1992. This home currently stands at the corner of Ruth Street and Route 18. It was built in the late 1700s for the Eggers family. The home was moved to this spot in the early 1950s when it was threatened with demolition. Howard Malkin utilized the structure for his business Malkin's Functional Footwear.

Two

A REVOLUTIONARY HISTORY

The Revolutionary War impacted central New Jersey, and although East Brunswick had yet to be incorporated, the war came to the doorsteps of the people who lived in the area. The British occupied the Raritan Valley from December 1776 to June 1777 and caused much turmoil. Foraging parties often raided local farms for supplies that were needed to feed the large numbers of troops and horses. In response, the local militia—made up of farmers whose lands were under threat—responded in kind by harassing these parties any time they stepped outside the safety of the main army in New Brunswick.

It was against this backdrop that the people living in what would become East Brunswick witnessed a daring raid on a British outpost on Bennett's Island along the Raritan River. The stunning predawn raid on February 18, 1777, led to the capture of 60 British soldiers, including Maj. Richard Stockton. The capture of this strategic location came after the victories at the Battle of Trenton and Princeton and continued to boost the morale of the Revolutionary soldiers. Gen. George Washington would go on to laud the actions of those who fought at Bennett's Island in several letters written days afterward.

Washington passed through parts of East Brunswick after the Battle of Monmouth, which was fought on June 28, 1777, near Freehold. After the battle, Washington and his troops traveled to New Brunswick, camping overnight in the Old Bride section of town.

The area rebuilt after the war, and East Brunswick prospered as new arrivals attracted to the area began to farm the land and build permanent structures. Veterans of the war were included in this new generation.

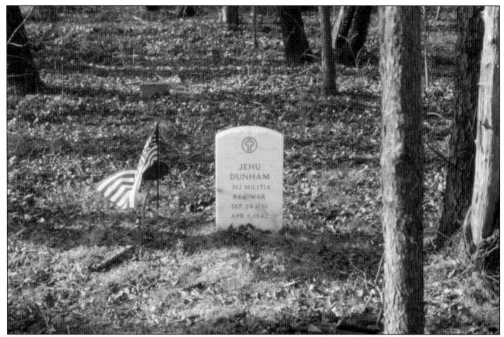

JEHU DUNHAM GRAVE MARKER. Along Longzak Drive in East Brunswick, within the Summerhill Meadows development, is an open field with a clump of trees along the edge. The trees are the location of the Obert family burial ground. A marker commemorating Jehu Dunham is located in the small family cemetery. Jehu was born on September 21, 1761, in what is now South River borough. He joined the New Jersey Militia and participated in the Battle of Springfield. He served until 1782 and passed away on April 6, 1842. His original grave marker has long been lost, but a modern veteran's marker—issued by the federal government—is in its place today. This photograph was taken around 1988. (Mark Nonestied.)

BATTLE FOR BENNETT'S ISLAND. On February 18, 1777, Col. John Neilson of the New Jersey Militia attacked the outpost at Bennett's Island with about 150 militia men and 50 Pennsylvania riflemen. The daring predawn raid led to the capture of 60 British soldiers, with 4 British soldiers and 1 American soldier killed in the conflict. This modern photograph shows the island in a view from across the Raritan River at the Edison boat dock. (Photograph by Mark Nonestied.)

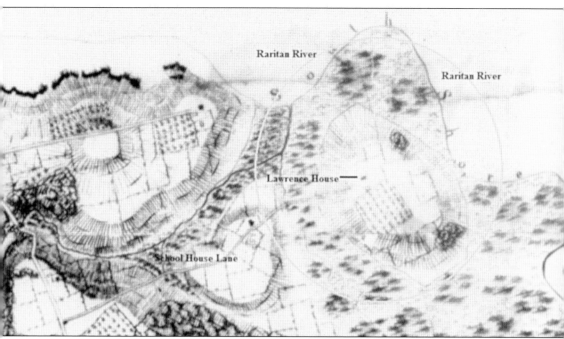

Coastal Survey Map, 1840. From December 1776 to June 1778, the British occupied the Raritan Valley. With the main force located in New Brunswick, strategic outposts were set up along the Raritan River to protect the city from attack by water. One of those outposts was located at the home of Thomas Lawrence on Bennett's Island. This map shows the Lawrence home and property. Its strategic location—sitting on a bluff overlooking the Raritan River—is apparent. (University of Alabama, with notations added by Mark Nonestied.)

AERIAL PHOTOGRAPH OF BENNETT'S ISLAND. The streams that made up the island disappeared in the 1800s. The site remained relatively untouched until the 1950s, when Edgeboro Landfill was created. This picture shows the site today.

ARTIFACTS FROM BENNETT'S ISLAND. This photograph shows several historic artifacts uncovered on Bennett's Island by archaeologist Dorothy Cross in the 1930s. The artifacts were photographed at a later date by Ann and Manny Alvarez. The assemblage consists of clay pipe fragments, including the bowl and stem portions of the pipe. At lower right is an animal tooth, possibly from a boar. (Ann and Manny Alvarez.)

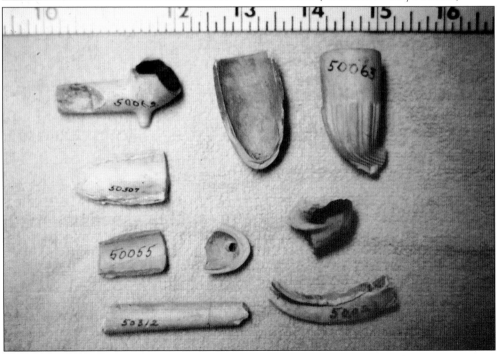

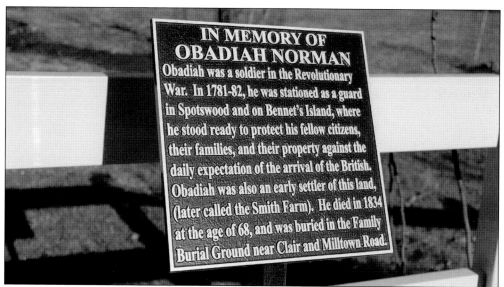

COMMEMORATIVE PLAQUE FOR OBADIAH NORMAN. Obadiah Norman was a veteran of the Revolutionary War who served from 1781 to 1782. He applied for a pension after the war, noting that his duty was to "the defenseless families and property of his fellow citizens . . . against the daily expectation of the arrival of the enemy." He died on August 26, 1834, and was buried on his property. The land later became the Smith farm, and today, the East Brunswick Historical Society is housed in the old farmhouse on Milltown Road. Norman's grave has been lost to time, but the historical society erected this commemorative plaque to honor his memory. (Photograph by Mark Nonestied.)

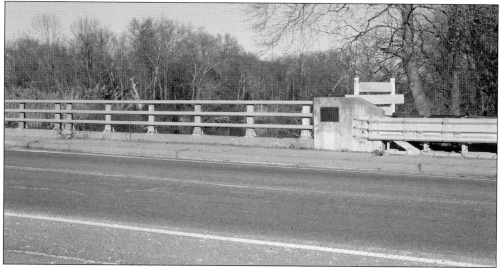

THE SITE OF THE OLD BRIDGE. After the Battle of Monmouth, George Washington and his troops traveled from Freehold to New Brunswick. They passed through the southeast corner of what would become East Brunswick Township and were reputed to have camped at the Old Bridge that crossed the South River. The Old Bridge section of East Brunswick still survives and is now the township's historic district. The location of the Old Bridge was along Matawan Road near the American Legion post. This image shows the modern bridge at that location. (Photograph by Mark Nonestied.)

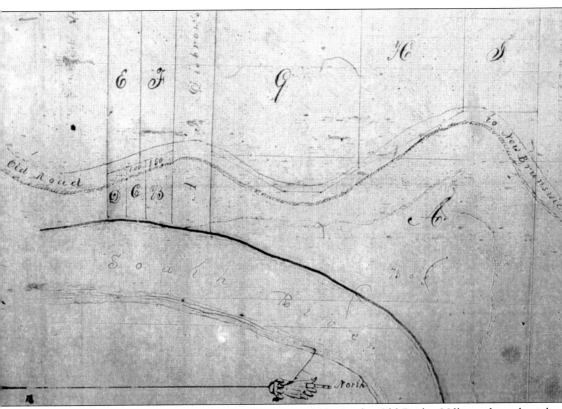

SURVEY OF LANDS OWNED BY MARY BISSETT, 1849. At the Old Bridge Village, the colonial roads split, with one road crossing the South River and heading to South Amboy. Other roads headed northeast. The route that is now River Road is perhaps one the earliest paths toward New Brunswick that winds along the South River. George Washington and his troops would have traveled to New Brunswick along these early routes. By the early 1800s, the Old Bridge Turnpike had been laid out as an improvement over the earlier roads. An 1849 Bissett family property survey showed the "Old Road to New Brunswick" (now River Road) as it headed uphill out of the historic district. (Photograph by Mark Nonestied.)

Three

EAST BRUNSWICK
FROM 1860 TO 1899

East Brunswick Township was officially formed on February 28, 1860. The boundaries included the now-separate communities of Helmetta, Spotswood, South River, and parts of Milltown. Each of these communities formed on their own during the 1800s, with Spotswood being the last to be incorporated (in 1908). In 1860, the population of the township consisted of 2,436 people who mainly lived on farms. While farms were common at that time, the township was still wooded with pine, maple, cedar, and varieties of oak. Historian W. Woodward Clayton noted in *History of Union and Middlesex Counties*, however, that by 1882, most of the timber had long since disappeared "before the axes of wood-cutters and ship-builders."

Within this rural landscape arose communities centered around trade and manufacturing. Weston's Mill was located along the Lawrence Brook near the present-day location of interchange 9 of the New Jersey Turnpike. Although it is mostly gone today, Weston's Mill consisted of mills, a hotel, and a school. The Old Bridge section of East Brunswick was another community. Located at the head of navigation for the South River, the neighborhood developed as a shipping point, with docks, stores, pottery and lime kilns, a fanning mill, and even a nearby gunpowder mill. The Camden & Amboy Railroad, the first railroad in New Jersey, had tracks laid through the community in 1832, further contributing to its growth.

In 1880, the total real estate valuation of East Brunswick was $789,170. By the close of the 19th century, the population had not increased much from that of 1860, although this was mostly due to East Brunswick decreasing in size as other communities developed out of it.

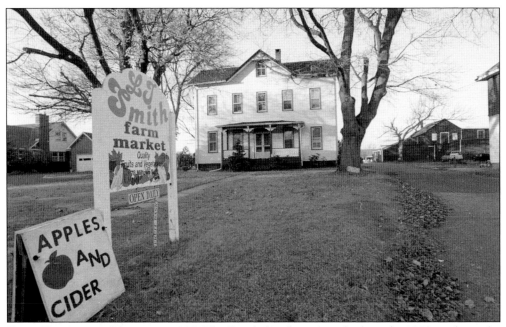

SMITH FARMHOUSE, NOVEMBER 1997. The Smith farmhouse was built in the 1860s and was the home of the Smith family. George Smith and his son Lawrence operated one of New Jersey's largest apple orchards. They used modern technology, including building one of the earliest cold storage buildings in 1912, to grow and preserve their crops. Today, the farmhouse building houses the East Brunswick Historical Society.

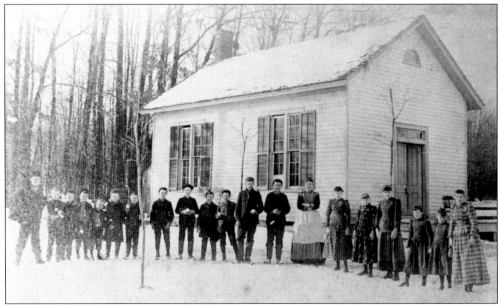

DUNHAM'S CORNER SCHOOL, C. 1894. The Dunham's Corner section of East Brunswick, located near Ryders Lane, grew as a small community and was named after Jehu Dunham, a veteran of the Revolutionary War. This building would eventually become the town hall, then the public works office, and finally, as part of the original Playhouse 22 building. When the playhouse moved to its current location on Cranbury Road in 2006, the original structure was demolished.

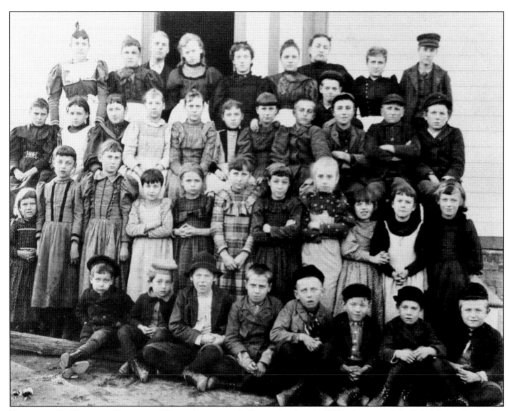

DUNHAM'S CORNER SCHOOL. This photograph from the late 1800s shows schoolchildren from the Dunham's Corner section of East Brunswick standing in front of the Dunham's Corner School.

DUNHAM'S CORNER POST OFFICE TREES, 1970s. During the late 1800s and early 1900s, residents living in the Dunham's Corner section of East Brunswick created their "post office" in the form of two giant oaks. Residents retrieved their mail from mailboxes attached to these trees. The trees have long since been cut down. (Ann Alvarez.)

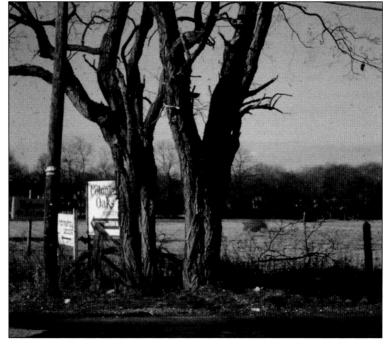

LAWRENCE BROOK SCHOOLHOUSE, 1970s. This one-room wooden school building was located on Riva Avenue near St. Mary's Coptic Orthodox Church. It was replaced by the Weber School in 1924. The older building was then converted to a home and remained standing, with the original school doors in place, but it was torn down around the mid-1990s to make way for St. Mary's expanded parking lot. (Ann Alvarez.)

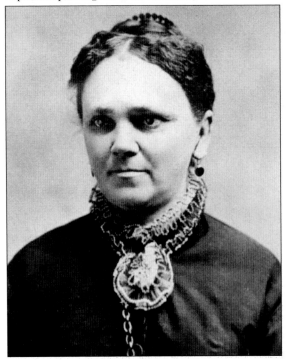

ANN ELIZA CONOVER. The Home Boarding School for Children was a private school started by Ann Eliza Conover in 1849. Conover enlarged her residence in 1865 to accommodate the growing number of pupils. The original building suffered a fire in the 1950s, but it still stands today as a private residence at 45 River Road.

GEORGE YATES PAINTING OF A SCHOOLMASTER. This small painting on a wooden board was done in the 1880s by resident George Yates, who lived in the Old Bridge section of East Brunswick. The painting depicts one of Yates's teachers, whose name has been lost to time. In 1881, the number of school-age children in East Brunswick was 793, with 177 attending private school and 200 not attending any school. Male teachers had an average salary of $43.50, while female teachers made $32.

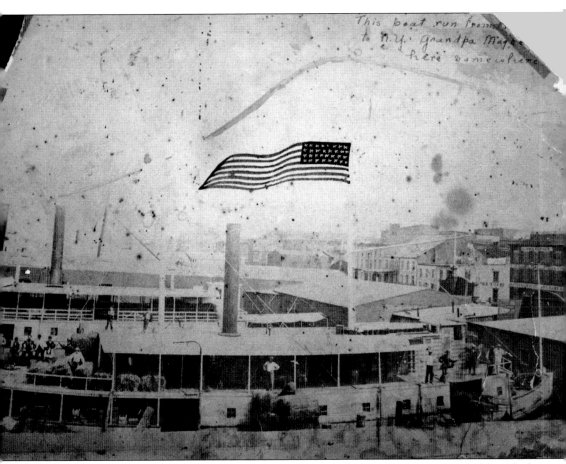

MARKET BOAT. This image shows a steam cargo boat docked in New York City. Although the corner of the image (noting where the vessel sailed from) is missing, these types of steamships could be found along the South River bringing farm produce to larger coastal markets. "Grandpa Magee," whose name is noted on the image, worked on this boat and lived in the Old Bridge section of East Brunswick. Accessibility to water transportation was critical to the early development of the area, as large volumes of goods could be shipped to markets quicker via water than over land. One of the last regularly scheduled market boat runs from the docks in the Old Bridge section was in 1914, closing out well over a century of shipping cargo from that location. (Mark Nonestied.)

LONE PINE FARMHOUSE, MID-1970S. Located at 350 Cranbury Road, the Lone Pine Farmhouse was built in the 1830s and expanded at a later date. The home was once part of the Smith farm and is where longtime East Brunswick resident Grace Auer was born in 1910. In 1937, she and her husband, Charles, built the neighboring house so they could continue to be close to their family. Grace was instrumental in many East Brunswick organizations and passed away in 2001.

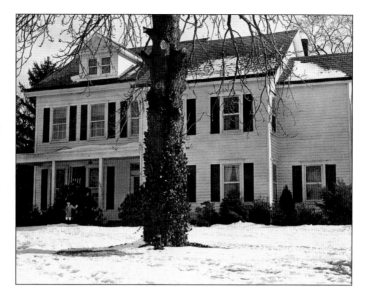

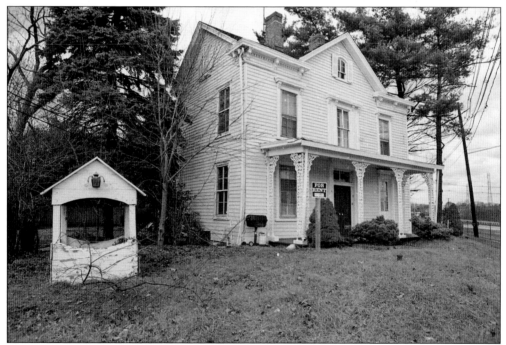

MARION THOMAS HOUSE: COSMOPOLITAN HOTEL, DECEMBER 1992. The Cosmopolitan Hotel was originally built as a home in the early 1800s. It was later expanded to serve travelers along the route to New Brunswick. The building later served as the antique store of Marion Thomas. When Route 18 was widened in the 1990s, a sound barrier was erected along the right-of-way. Since the home was listed in the state and national registers of historic places, the New Jersey Department of Transportation designed the clear sound barrier to preserve the view of the home, which still stands today.

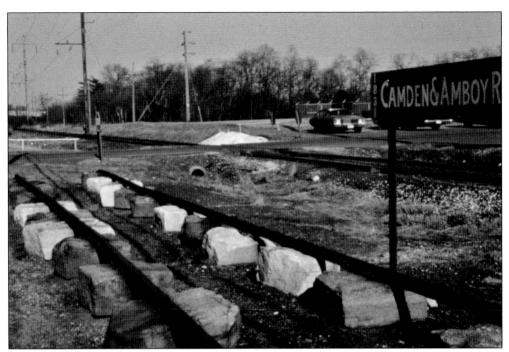

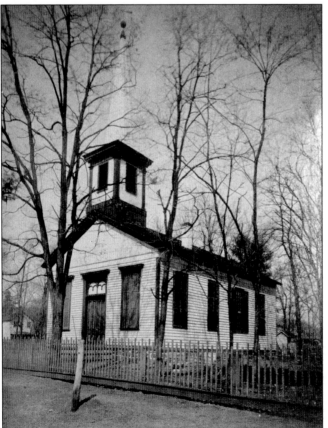

CAMDEN & AMBOY RAILROAD STONE SLEEPERS, 1970S. The Camden & Amboy Railroad was the first railroad in New Jersey. The company was chartered in 1830 and had tracks laid by 1832. The iron rails were originally anchored to stone blocks called sleepers. A small section of track was preserved for many years in front of the Anheuser-Busch factory along Main Street.

OLD BRIDGE BAPTIST CHURCH, APRIL 1975. The Old Bridge Baptist Church still stands on the corner of Kossman Street and Emerson Road in the township's historic district. The building was originally constructed in 1844 but was lifted up and turned to face Kossman Street in 1898.

RACETRACK LOVING CUP TROPHY. Racetrack Road in East Brunswick was named after the track that was once located there. The racetrack was used for both horse and bicycle races. This loving cup trophy was awarded for a race held on August 12, 1897. (Mark Nonestied.)

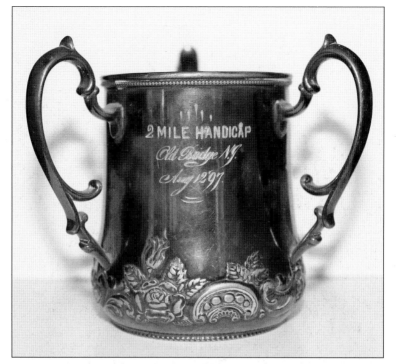

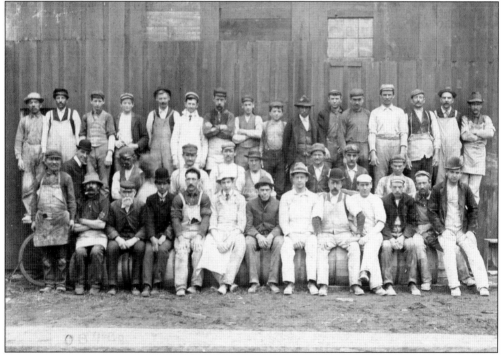

WORKERS AT THE OLD BRIDGE ENAMEL BRICK AND TILE COMPANY. The Old Bridge Enamel Brick and Tile Company was formed in the 1890s and closed in 1927. The company produced a variety of tiles, including decorative pressed examples. The factory was located on Bordentown Avenue and parts of it remain standing today after being reused by other companies. (Mark Nonestied.)

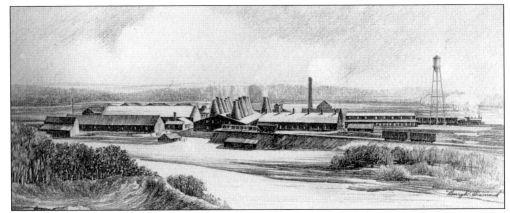

SKETCH OF THE OLD BRIDGE ENAMEL BRICK AND TILE COMPANY. This sketch of the Old Bridge Enamel Brick and Tile Company was done from the opposite bank of the South River by Henry R. Diamond and photographed by Palmer Shannon Studios in New York City. The image shows the many kilns used to fire the tiles. (Mark Nonestied.)

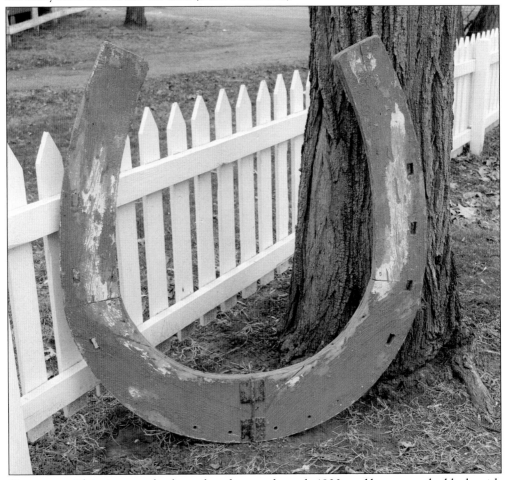

HORSESHOE. This giant wooden horseshoe dates to the early 1900s and hung over the blacksmith shop that was part of the Old Bridge Enamel Brick and Tile Company.

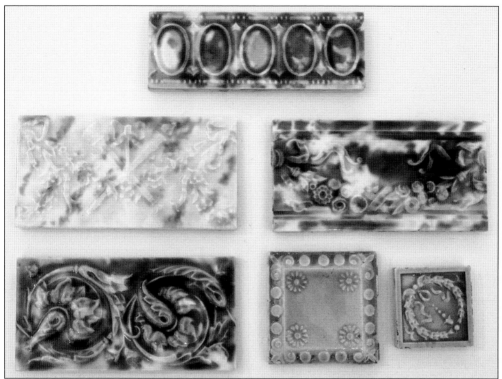

EXAMPLES OF TILES. The Old Bridge Enamel Brick and Tile Company produced a variety of tiles that ranged from octagonal floor tiles to pressed designs. The East Brunswick Museum has a collection of tiles that were donated or are on loan and show the variety of tiles produced by the company. (Photograph by Mark Nonestied.)

SHIPPING CRATE. At the Old Bridge Enamel Brick and Tile Company, tiles were fired in large kilns and then inspected for imperfections. Tiles with imperfections were discarded on the property and around the neighborhood. To this day, Old Bridge tiles found near the factory grounds are often used for fill or as an aggregate in concrete. Tiles that passed the inspection processes were packed in wooden crates for shipment. (Mark Nonestied.)

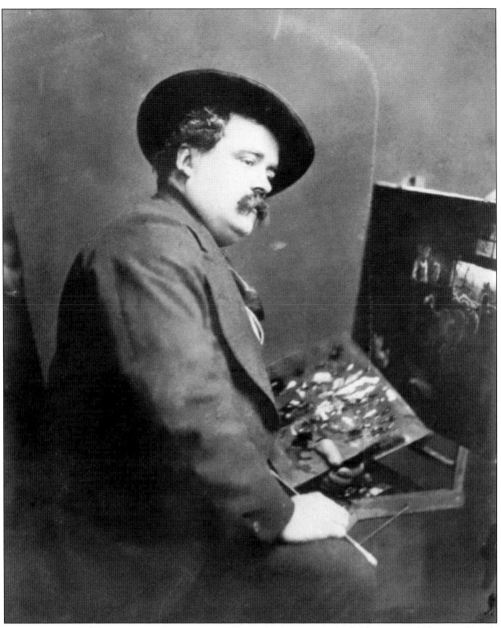

PHOTOGRAPH OF ARTIST JAMES CRAWFORD THOM. James Crawford Thom was born on March 22, 1835. He studied at an artist colony in Perth Amboy as well as at the National Academy in 1853. He refined his work in France and England. He married local resident Sarah Bloodgood in 1884 and lived at 10 Willow Street (now Kossman Street) in the Old Bridge section. He died in 1898 and is buried in Chestnut Hill Cemetery. (Mark Nonestied.)

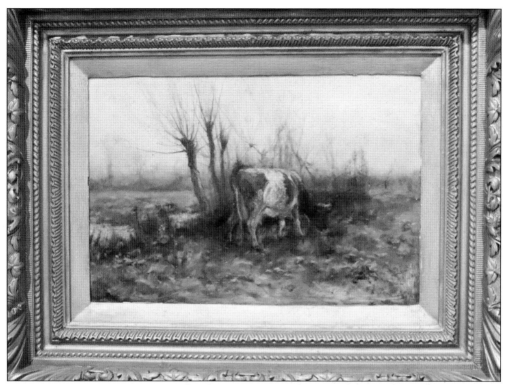

COW PAINTINGS BY J.C. THOM. The above painting was created by James Crawford Thom in 1887 during the period that he lived in East Brunswick. The low, flat, marshy land depicted here may have been inspired by the marshes along the South River. The East Brunswick Museum has one of the largest collections of James Crawford Thom paintings held by a public institution. Included in the collection are a number of study pieces, including the below image of a cow that is similar in theme to the above painting.

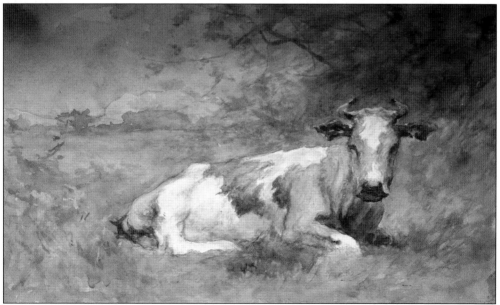

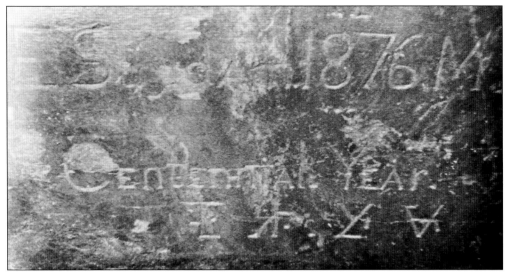

WESTON MILLS ROCK CARVINGS. In 1876, M. Danbury and Elias Suydam created a series of rock carvings on the shale outcroppings along the Lawrence Brook and the Raritan River. They carved the words "Centennial Year," the date "1876," and mysterious symbols, as shown in this image. The meaning of these symbols has been lost to time.

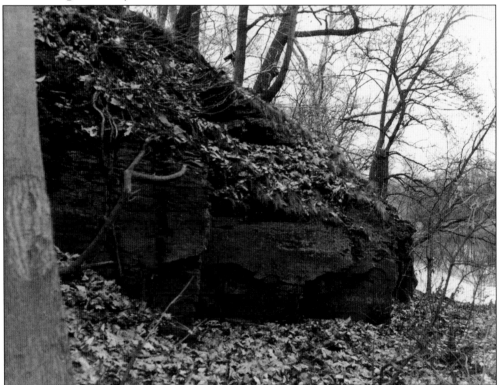

SHALE OUTCROPPINGS. This image shows the shale outcroppings behind Tower Center Drive along the Lawrence Brook. These outcroppings were used by M. Danbury and Elias Suydam for their carvings. At this location, they also carved a skull and crossbones and the words "Red Rover"—a reference to a sea novel written by James Fenimore Cooper in the 1820s.

Four

A NEW CENTURY

At the dawn of the 20th century, East Brunswick remained a relatively rural community. New immigrant populations, especially from Eastern Europe, began to settle in the township. During the 1920s and 1930s, highways and improved roads were developed because of the automobile. Route 18, originally known as State Highway 28, was built during this period. It connected New Brunswick with points south and the shore and paralleled an earlier road, the Old Bridge Turnpike, which had made the same connections.

Industrialization that began in the late 19th century continued into the early 20th with factories being built in the area, including the Philadelphia and Boston Face Brick Company, located where Southerland Drive is today. The factory produced decorative architectural brick for building facades and interior fireplace surrounds from 1910 to about 1918. In the 1930s, Anheuser-Busch opened a factory on Main Street to produce yeast. Many residents can still remember the smell that lingered throughout the nearby neighborhoods.

World War I impacted people across the globe, including those who lived in East Brunswick. Residents went off to fight in the war that was to end all wars only to find, some 20 years later, that a new generation of residents would be called to fight in another global conflict.

East Brunswick aimed to keep up with changing ways. A new generation of brick schoolhouses were built during this period to replace the earlier one-room wooden schools of the previous century. These new structures were sturdily built with large windows to let in natural light and ventilation. They also had multiple classrooms to accommodate different grades. In addition to school structures that engaged the minds of a young student population, East Brunswick opened its first library in 1944 for all its residents. The Alice Appleby DeVoe Memorial Library was housed in the historic Appleby Home on Main Street and served the community for many decades.

SCHOOL PHOTOGRAPH, 1901. This picture was taken in the Old Bridge section of East Brunswick. James E. Silvester is in the front row at far right, with Murray Chittick just behind him to the left. (Mark Nonestied.)

ZIEMINSKI FAMILY, 1918. In 1910, the Zieminski family purchased 48 acres of land in East Brunswick. The family farmhouse still stands today at 166 Rues Lane. This photograph shows Joseph and Mary Zieminski along with their nine children—Frank, George, Stephen, Harold, Raymond, Anna, Catherine, Pearl, and Bessie. An uncle visiting from Poland is also in the picture. (Zieminski family.)

Sgt Joseph B Crandall Co B. 9 Machine Gun Btn A E F
Report by 1st Lieut Thomas R Faber . . Same

Sgt Crandall was in charge of a section of my platoon on the night of July 14-15-1918 and was sent to relieve a section of D Company 9 M G Btn. The German barrage started before the relief was accomplished and Sgt Crandall being deserted by guides, held his section by the roadside. He was hit in the leg by a shell fragment early in the action, but remained with his section in spite of physical pain. Some two hours later a second fragment tore through his shoulder blade reaching vital organs, and caused instantaneous death. He was buried two days later in the Bois d'Angremont but since then the body has been removed to a place unknown to me.

Letter about Joseph B. Crandall. Sgt. Joseph B. Crandall was the son of local doctor Ira Crandall. The family lived at 152 Main Street in a home that still stands in the township's historic district. Thomas R. Faber wrote a report of Crandall's death on July 15, 1918, noting that he had been wounded in the leg by a shell fragment while holding a position along a roadside. Two hours later, he was killed by another shell fragment. Sergeant Crandall was buried in the Oise-Aisne American Cemetery in France. (Mark Nonestied.)

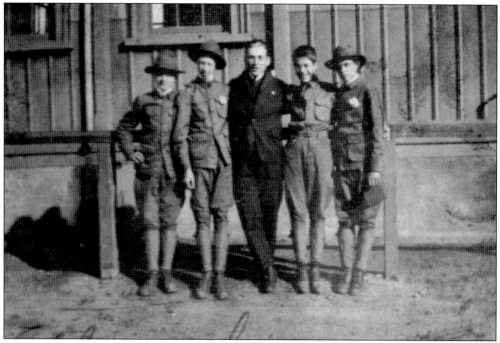

ELLSWORTH SILVESTER. Ellsworth Silvester (pictured in the center of this photograph) lived in the Old Bridge section of East Brunswick. He joined the service and was sent to Camp Dix, where he died in 1918 during the influenza pandemic. (Mark Nonestied.)

UNION CHAPEL. The Dunham's Corner Union Chapel was built in 1924. This brick structure was located near Pinehill Court and was demolished in 2006 for a housing development. This photograph was taken around 1988. (Mark Nonestied.)

STAINED-GLASS WINDOW. The Dunham's Corner Union Chapel featured stained-glass windows, including this large main window dedicated to Mrs. Charles V. Stults by the Women's Christian Temperance Union (WCTU). The WCTU was founded in the 1870s and reached its height of membership in the 1920s. The organization tackled social reform issues and was instrumental in the temperance movement. The window was removed from the church and is now on display at the East Brunswick Museum.

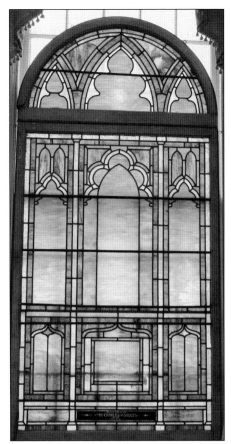

TRENTON FAST LINE. The Newark Trenton Fast Line was an interurban rail line later operated by Public Service Railway. Construction started in 1902 on the section between Milltown and Trenton, and regular service commenced in 1904. The line followed the current high-voltage right-of-way that travels along Route 1 and through East Brunswick along Riva Avenue. Operations ceased on this section of the line in 1936. The train line crossed Farrington Lake near Washington Place and Hardenburg Lane. This image from the late 1980s shows what was then left of the train trestle, with a section of rail in the right foreground. (Mark Nonestied.)

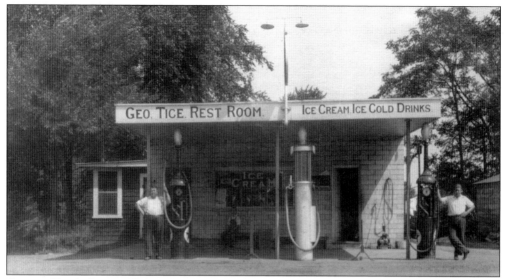

GEORGE TICE'S CORNER GAS STATION, 1931. The Tice family lived at the corner of Tices Lane and Old Bridge Turnpike as far back as the 1870s. This photograph shows the gas station the family operated on Old Bridge Turnpike near Matawan Road.

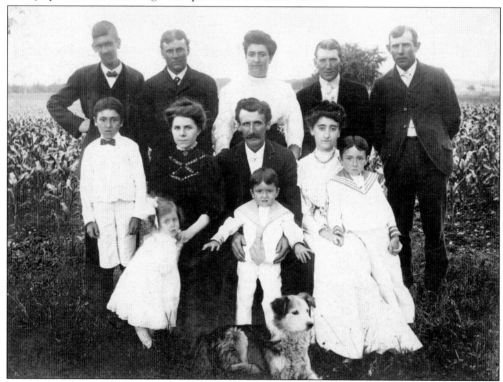

PETTY FAMILY PORTRAIT. The Pettys were some of the earliest residents to settle in what eventually became East Brunswick. The family property on Dunham's Corner Road was purchased by Jehiel Petty in 1847, and he grew a variety of berries there. By the time the farm was sold in 1956, the Petty family was the last family in East Brunswick to have maintained a farm since before the 1860 founding of the township. (Dorothy and Kathy Baird.)

DANIEL PETTY FARMING IN THE 1930s. Daniel Petty is shown plowing his farm on Dunham's Corner Road. (Dorothy and Kathy Baird.)

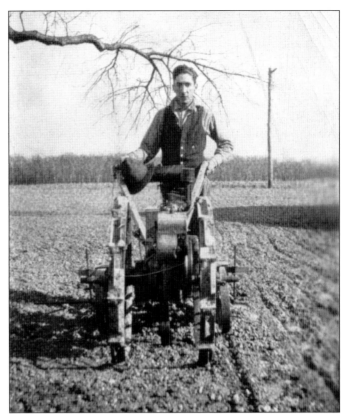

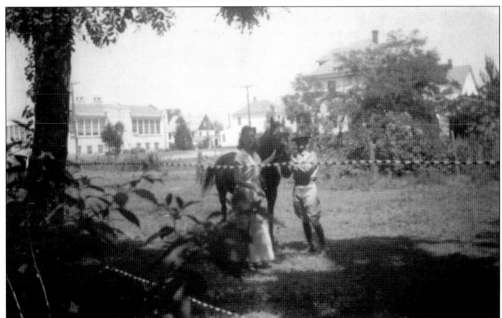

PRICE ESTATE, 1930s. The unidentified man and woman are pictured with a horse off Route 18 and Milltown Road near what was known as the Price estate. Wade School is visible in the background. This site is now home to Magnifico's Ice Cream. (Joann VanDeursen.)

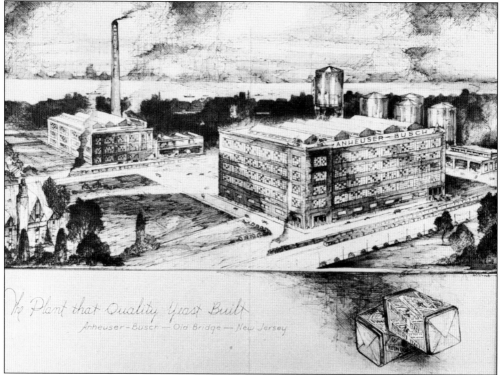

ANHEUSER-BUSCH FACTORY. In 1931, Anheuser-Busch awarded a contract to build a yeast factory on Main Street with the capability of producing 100,000 pounds of yeast per day. The factory included a machine shop, power plant, and garage and was reputed to cost $2 million to build. The factory closed in 1997, and the building was demolished in 2002. This artist's rendition of the factory is from the early 1930s.

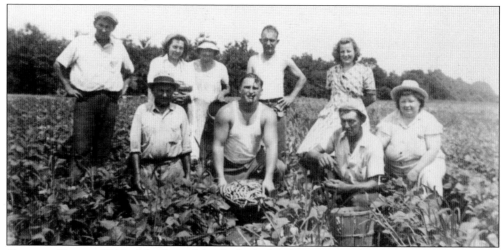

GARBOSKI FAMILY, 1940S. Members of the Garboski family are pictured working their farm on Rues Lane. From left to right are (first row) Martin Garboski, John "Red" Siewierski, Peter Garboski, and Sophie Garboski; (second row) Joe Garboski, Mary Garboski Siewierski, Rose Garboski, Frank Garbosky (whose last name ends in a y instead of an i), and Mary Jane Garbosky. This is now the site of Great Oak Park. (Garboski family.)

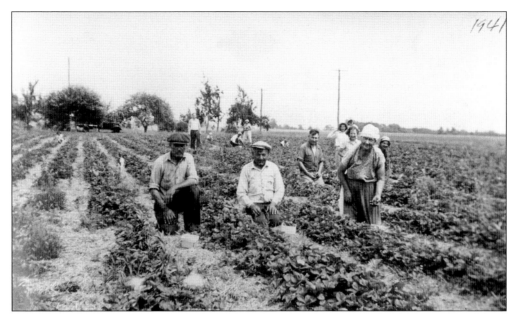

1941

MARTIN AND ROSE GARBOSKI, C. 1941. Martin (center) and Rose (right) Garboski are shown on their farm on Rues Lane. (Garboski family.)

McGUIRE FARM.
Mary McGuire and her father, Tom, are pictured at their apple farm in the Weston's Mill section of East Brunswick. Their family's farm was displaced by the construction of the New Jersey Turnpike and had to be relocated. (McGuire family.)

47

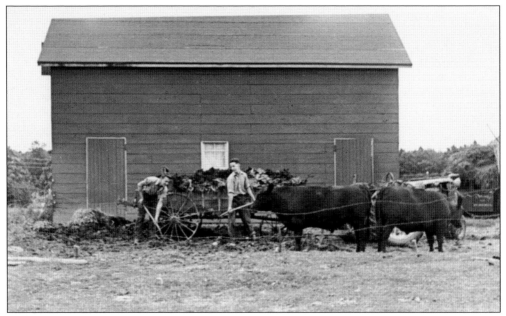

JOHN AND STANLEY GATARZ. John (left) and Stanley Gatarz (right) are pictured in the cattle pen at their farm on Ryders Lane, with their barn prominently shown in the background. (Gatarz family.)

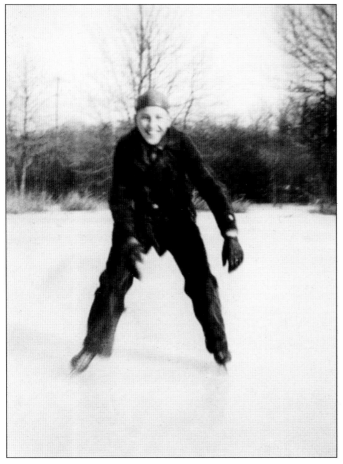

JOHN GATARZ ICE-SKATING, C. 1938. John Gatarz is shown skating at the pond on his farm on Ryders Lane; it is now known as the municipal pond. (Gatarz family.)

**STANLEY AND JUDY GATARZ,
c. 1942.** Stanley Gatarz
posed with his niece, Judy,
in the fields of his farm on
Ryders Lane. The farmhouse
visible in the distant
background was torn down
in 2016. (Gatarz family.)

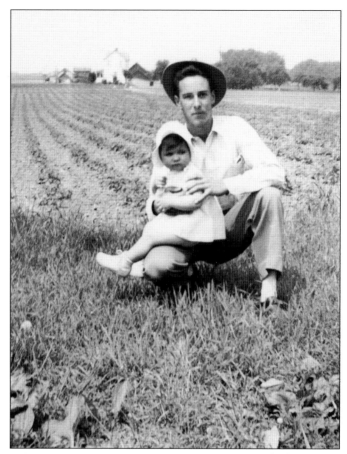

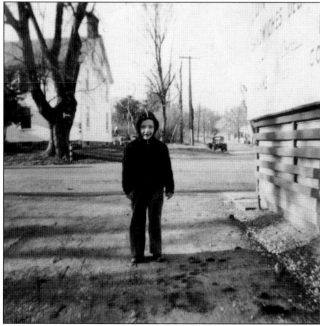

**BOY STANDING AT MAIN
STREET AND OLD BRIDGE
TURNPIKE, 1940S.** This image
features a boy whose name
has been lost to time. The
historic Cole house is visible
in the background at left, and
the Old Bridge Turnpike is
shown in the background at
right as it heads up toward
Chestnut Hill Cemetery.

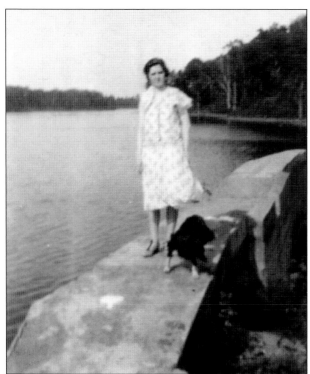

FARRINGTON LAKE DAM. The Connollys were a wealthy family that owned a summer estate on the site of a former plantation along Farrington Lake. They constructed their own dam on the lake, but it broke in two for unknown reasons. The dam, along with the family's entire property, is now part of Bicentennial Park. Dr. Anna Marie Connolly is shown standing on the dam. (Connolly family.)

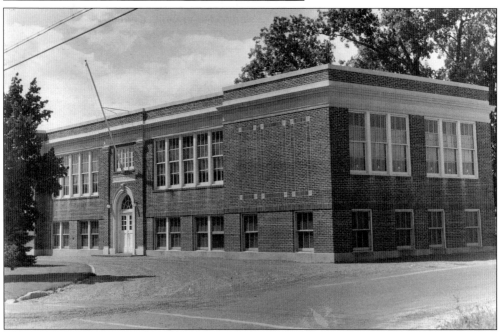

WEBER SCHOOL, APRIL 1956. Weber School was built in 1924 and named for Emil E. Weber, who had served on the board of education. This building replaced an earlier wooden schoolhouse that had become overcrowded and inefficient. The second generation of school structures in East Brunswick were built using fireproof materials and had large windows to let in natural light and air. This building still stands today on the corner of Riva Avenue and Hardenburg Lane.

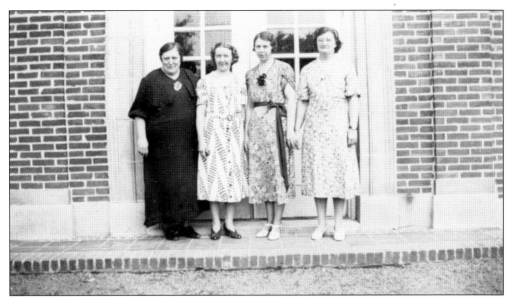

WEBER SCHOOL PTA. The Parent Teacher Association has always been a vital part of the East Brunswick School District. The PTA at Weber School was responsible for it being one of the first schools in New Jersey to provide hot lunches for its students under a Works Progress Administration program. These are the PTA members for the 1937–1938 school year.

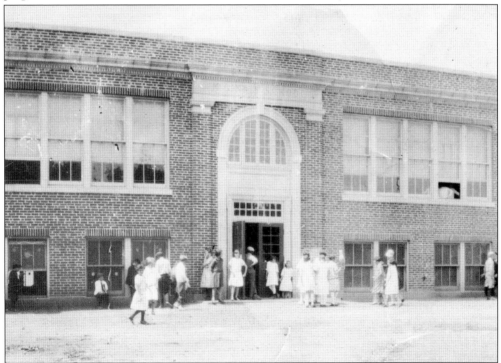

MCGINNIS SCHOOL, 1930S. McGinnis School was located at the corner of Dunham's Corner Road and Hardenburg Lane. The building was erected in 1926 and named for board of education member Peter McGinnis, who passed away in 1909. The building was demolished in 2015, and a similarly styled structure was built in its place and is now the Torah Links of Middlesex County.

MRS. WARNSDORFER AT MCGINNIS SCHOOL, OCTOBER 1935. Mildred Dawson Warnsdorfer began teaching in East Brunswick schools in 1921. Five years later, she became the teacher-principal at the newly opened McGinnis School, where she would spend the next 37 years of her teaching career. She was beloved by many of the students whom she taught over the years. Warnsdorfer Elementary School would be named for her and the family she married into. (Gatarz family.)

DALLENBACH HOUSE, JULY 1978. This historic house near Dunham's Corner Road and Church Lane served as the offices for the Dallenbach Sand Company. The house has since been demolished. Lois Herbert is shown standing in front of the structure.

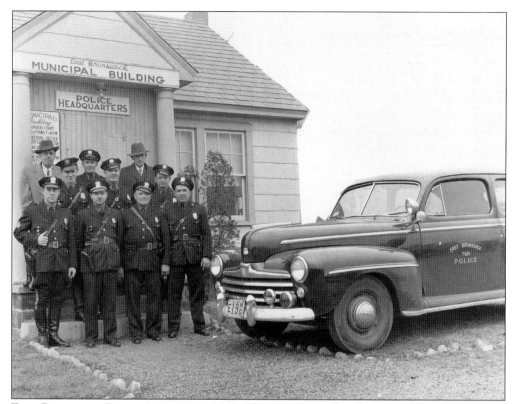

EAST BRUNSWICK POLICE RESERVE, C. 1949. The township police force was formed in 1929. At that time, it was a part-time force that was housed in a small room in the back of a barbershop, then in a small structure on Route 18 and North Woodland Avenue. In 1941, the force moved into this bungalow on Wallace Street, where it remained for over 30 years.

MIDDLESEX COUNTY PISTOL RANGE, 1930s. Around this time, recreational offerings were limited in East Brunswick. One of the few activities available for a brief period was this shooting range off of Route 18. Located behind the Golf Row Garage near present-day Edgeboro Road, the Middlesex County Pistol Range was a popular spot for pistol matches and gun training. The shooting range was inactive by the early 1940s.

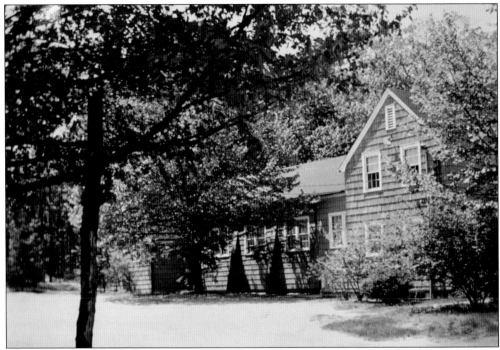

EAST BRUNSWICK GRANGE. The East Brunswick Grange Hall was built in 1936 and stood near the corner of Rues Lane and Dunham's Corner Road. The grange was founded as the Milltown Grange in 1905 and was an active support organization for area farmers. It was instrumental in the formation of the Middlesex County Fair. (Archives of the East Brunswick Grange.)

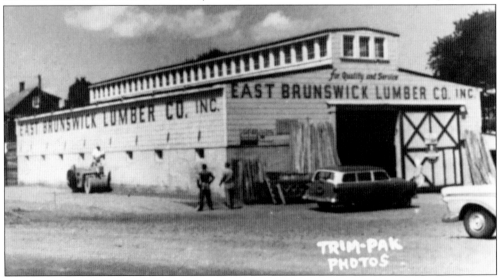

EAST BRUNSWICK LUMBER COMPANY. When Route 18 (then Route S-28) was built through the township in 1931, many entrepreneurs sought the opportunity to establish businesses along the heavily traveled highway. The East Brunswick Lumber Company was among those early businesses. Started by William Dickson and Chris Jorgenson in 1933, the company became a longtime staple for the Route 18 business corridor. Located at the intersection of the highway Cranbury Road, the company remained in business until the early 1990s. (Louis and Joy Goldstein.)

Five

POSTWAR SUBURBIA

The postwar years would usher in some of the greatest change in East Brunswick as the community shifted from a rural agricultural landscape to a built-up suburbia. Between 1950 and 1960, the population increased from 5,699 to 19,965. By 1970, the population had increased to over 34,000. Within these few decades, East Brunswick was transformed and would lay the foundation for the change that continues to this day.

Several factors contributed to this explosive growth. The decay and decline of urban areas, along with the improved road system and affordable housing opportunities, saw people move in great numbers. For residents who came to East Brunswick during this period, it was the ideal place—it had a balance of farms and nature along with modern homes and communities that provided good schools, local shopping, and amenities.

The growth of East Brunswick during this period also put pressure on the township's infrastructure. New water and sewer systems needed to be built, and things like sanitation collection and the maintenance of roads had to be taken care of. The East Brunswick Public School system needed to grow along with the population in order to accommodate the new students coming into the area. Many of the schools still in use today date from this period of development.

East Brunswick celebrated its centennial in 1960. Many changes had taken place, and those who lived in East Brunswick in 1860 likely would not have recognized the township 100 years later. These tremendous changes created both challenges and new opportunities for residents.

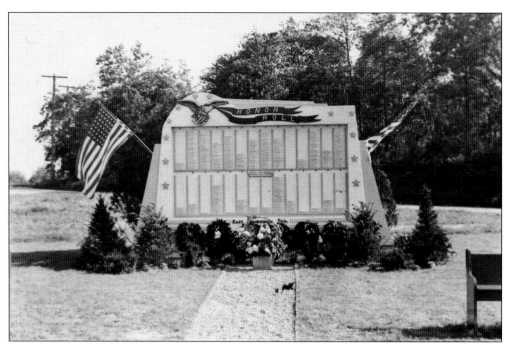

EAST BRUNSWICK HONOR ROLL. In 1945, following the end of World War II, the township erected this monument to honor those residents who served in combat. The monument stood in the triangle at the intersection of Ryder's Lane and Milltown Road. It was removed a short time later when the road was widened.

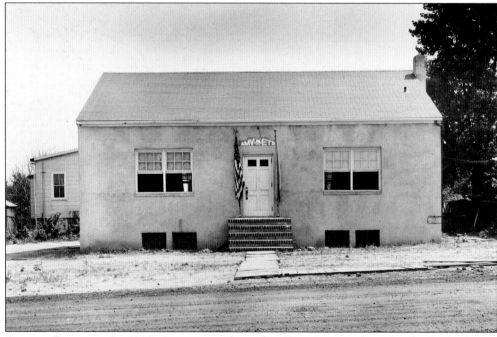

AMVETS BUILDING. In 1946, Amvets was formed in East Brunswick under the leadership of Charles Sullivan. Soon after, construction began on this structure on Joseph Street to be used as the group's headquarters. The building was formally dedicated in 1952.

HILLTOP BOULEVARD CONSTRUCTION, 1947. This image shows Hilltop Boulevard under construction with Milltown Road in the background. (Jonathan Gaertner.)

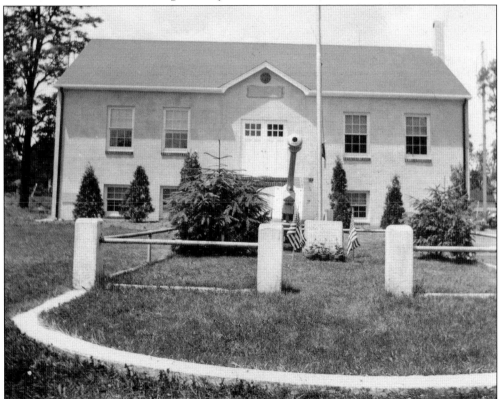

CRANDALL-KOSSMAN AMERICAN LEGION HALL, MAY 1949. This is the Crandall-Kossman Post No. 177, American Legion Hall, on Emerson Street and Matawan Road. The organization still maintains this building that was constructed in 1949.

VICTORY GARDEN APARTMENTS, FEBRUARY 1949. These apartments were constructed as part of an emergency housing project for veterans who served during World War II. These were the first affordable apartments built in East Brunswick. At the time, rent was $45 per month.

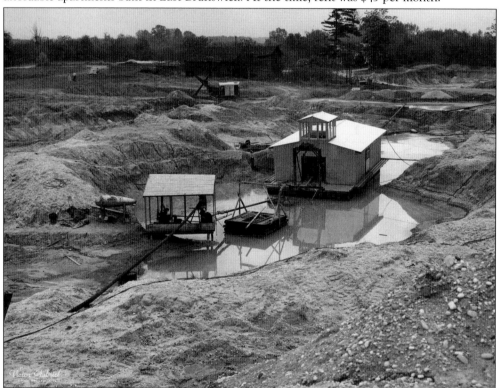

HERBERT SAND COMPANY, MAY 1949. East Brunswick is split between two geological features—the inner coastal plains and the piedmont region of the state. The sandy soil of the coastal plains was mined for sand, including for its use in foundry molds. This image shows the Herbert Sand Company on Church Lane and Beekman Road.

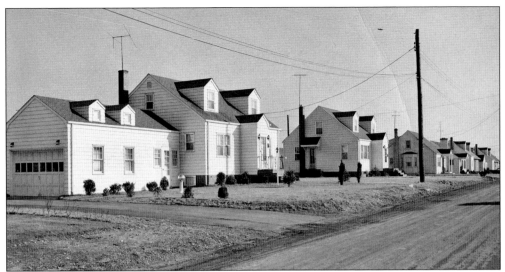

TANNER'S CORNER, C. 1950. The 1950s marked the beginning of a development boom for East Brunswick as more residential neighborhoods were being constructed. These homes were built in the Tanner's Corner section of East Brunswick on Prigmore Street.

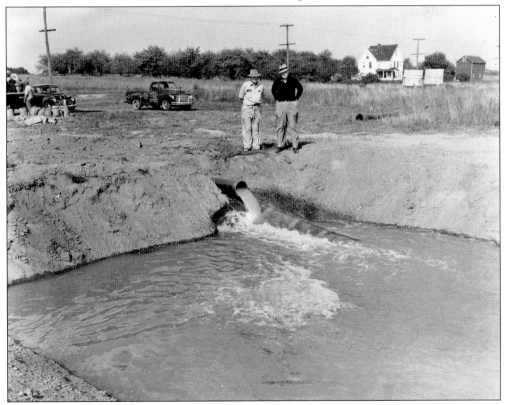

EAST BRUNSWICK PUMPING STATION. The postwar development of East Brunswick required improved infrastructure throughout the township. The development of water and sewer systems on a large scale had roots in the 1950s. This water-pumping station was located on Rues Lane. Mayor Charles Sullivan is the man at right.

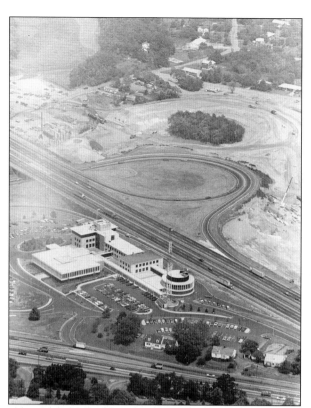

NEW JERSEY TURNPIKE. The New Jersey Turnpike Authority was incorporated in 1949, and construction on the turnpike started soon after. The authority's headquarters was located at interchange 9 in East Brunswick. The building still stands but is no longer utilized. (Rosalie Littlefield.)

MIDDLESEX SHEET METAL. The Middlesex Sheet Metal Company was located off of Route 18. Originally located in Milltown, the company moved into this structure in 1945. The company specialized in the construction of various materials, including air conditioners, ventilators, exhaust systems, tanks, and stackers. The company moved to Jamesburg in 1981. This site is now occupied by a motel complex.

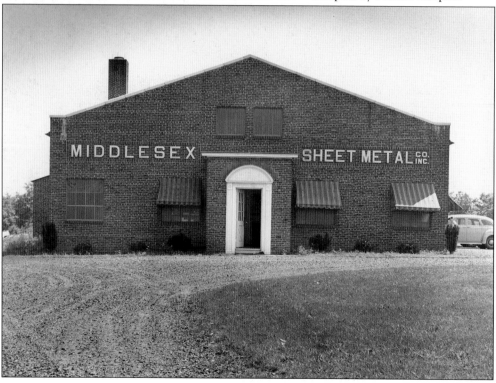

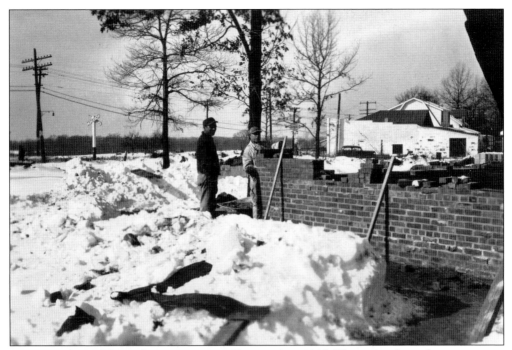

MIDDLESEX SHEET METAL CONSTRUCTION ON ROUTE 18, C. 1945. This image shows the construction of the Middlesex Sheet Metal Company off of Route 18. In the background is the railroad crossing for the Raritan River Serviss Branch that crossed the highway.

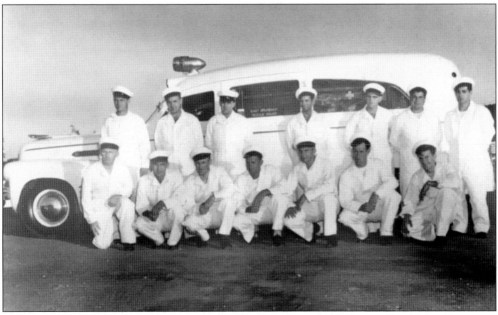

EAST BRUNSWICK RESCUE SQUAD, C. 1953. The East Brunswick Rescue Squad was organized in 1952 at the Amvets Hall. Prior to this, rescue squad services were provided by South River, Milltown, and Spotswood. When it started, this squad had only 12 volunteer members. By the following year, the squad was able to secure funds to build its own headquarters on Prigmore Street. Several of the original crew members are pictured here.

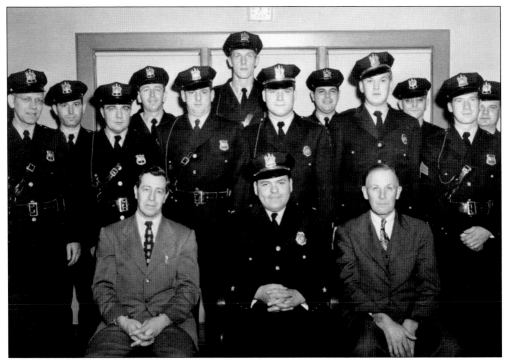

EAST BRUNSWICK FULL-TIME POLICE FORCE, C. 1953. In 1953, under the direction of Mayor Charles Skistimas, a Republican, the East Brunswick Police Force was briefly turned into a full-time force. However, after less than a year, the department was demoted back to part-time under Mayor Louis May, a Democrat. The department did not become permanently full-time until 1960. (Ron Frankosky.)

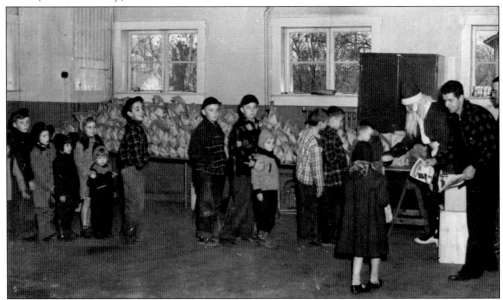

CHRISTMAS AT THE OLD BRIDGE FIREHOUSE. When the holidays came around, the Old Bridge Volunteer Fire Company would hand out bags of treats, usually consisting of fruit or candy, to children in the area. Francis Davala is standing next to jolly old Saint Nick.

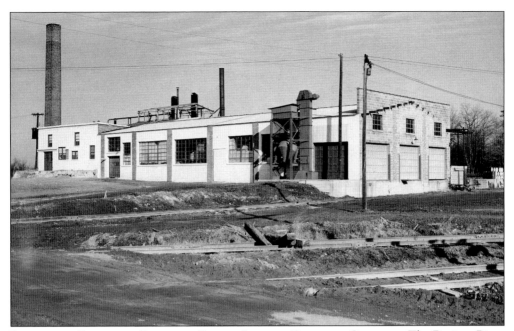

INDUSTRIAL COMPOUND BUILDING, RYDERS LANE AT RAILROAD CROSSING. The Raritan River Railroad was chartered in 1888 and ran from South Amboy to New Brunswick. It provided transport for both passengers and freight. A number of factories opened along the railroad's right-of-way. Commercial operations expanded over the decades. This industrial building was located at Ryder Lane near the Raritan River Railroad crossing.

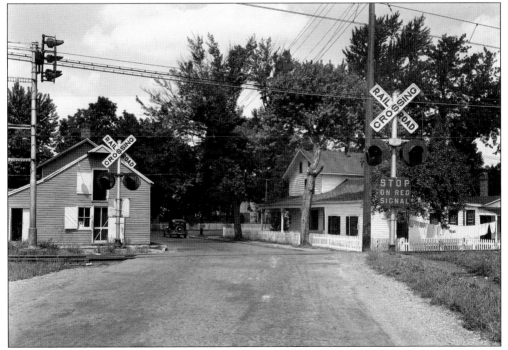

EMERSON STREET, AUGUST 1954. This image of Emerson Street shows a view looking toward Main Street. The Appleby General Store, built in the 1820s, sits on the corner at left. (Ron Frankosky.)

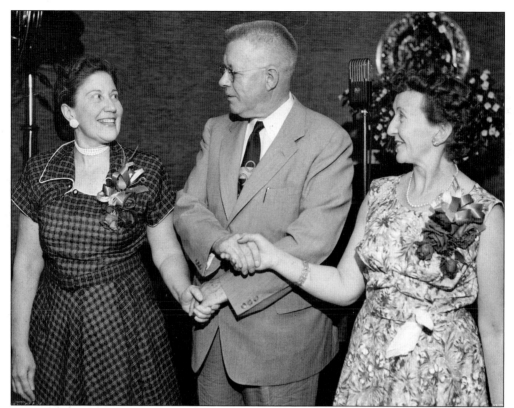

MURRAY CHITTICK TESTIMONIAL DINNER, JUNE 1954. Superintendent of schools Murray A. Chittick witnessed the major growth of the school system during his more than 30 years working in the system as small schoolhouses transitioned to multiroom facilities. Here, he is being honored at a testimonial dinner alongside teachers Cecilia Dougherty (left) and Lillian Swales (right).

SUNOCO GAS STATION ON ROUTE 18, MID-1950s. This gas station was located along the northbound lanes where Old Bridge Turnpike merges with Route 18 near Edgeboro Road. By this time, the railroad tracks of the Raritan River Serviss Branch that crossed the highway had already been torn up as the turnpike came through.

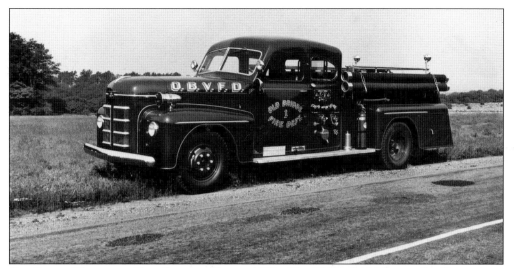

OLD BRIDGE VOLUNTEER FIRE COMPANY TRUCK, 1950S. The Old Bridge Volunteer Fire Department purchased this 1947 Ahrens-Fox truck as part of their roster of equipment. The vehicle still survives today.

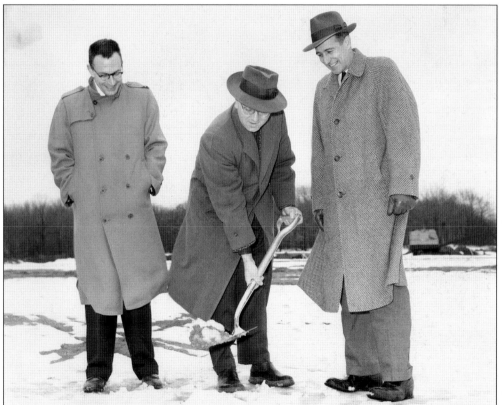

GROUNDBREAKING FOR THE HIGH SCHOOL, DECEMBER 1957. Board of education member Aleck Borman (center) is shown breaking ground for East Brunswick High School off of Cranbury Road. Superintendent Dr. S. David Adler is at left, and Mayor Louis May is at right. (Aleck Borman family.)

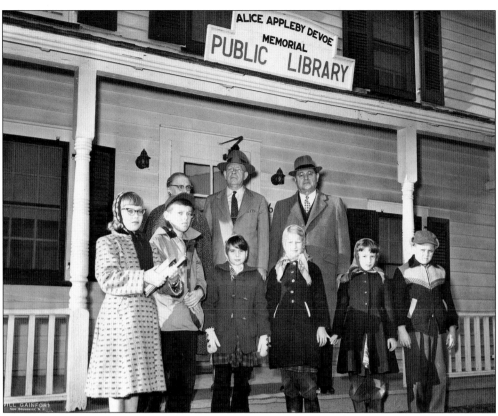

ALICE APPLEBY DEVOE MEMORIAL LIBRARY, JANUARY 1958. The Alice Appleby DeVoe Memorial Library became the township's first library when it opened in 1945. It was a gift to the township from Fred DeVoe as a tribute to his mother, Alice. This group of adults and kids is standing outside the library. Fred DeVoe is shown at upper right next to board of trustee Murray Chittick (center) and librarian Ann Austin (right).

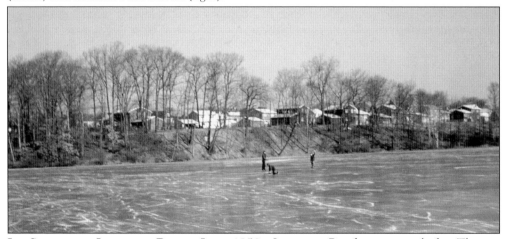

ICE-SKATING AT LAWRENCE BROOK, LATE 1950s. Lawrence Brook was named after Thomas Lawrence, a New York baker who settled in what would later become East Brunswick in the late 1600s. At Weston's Mill, a dam was built to power early mills, creating a millpond. This image of Lawrence Brook shows kids ice-skating on the pond. (Don Sauvigne.)

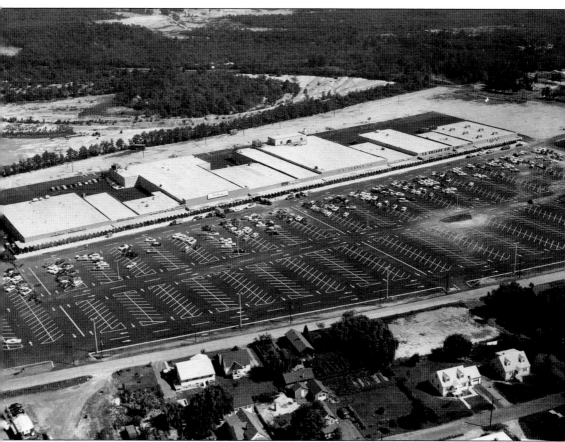

MID-STATE MALL OPENING DAY. Mid-State Mall opened in August 1958. It was built on an old swamp owned by the National Fireproofing Company that was originally to be used for mining. The mall was a prelude to the larger malls that were constructed throughout the region in later years. It had all the modern conveniences that shoppers of the 1950s valued, including a location with ample parking and a covered arcade that connected all the stores. Malls would later have an adverse impact on traditional shopping centers located in the downtown urban areas of New Brunswick, Woodbridge, and Perth Amboy.

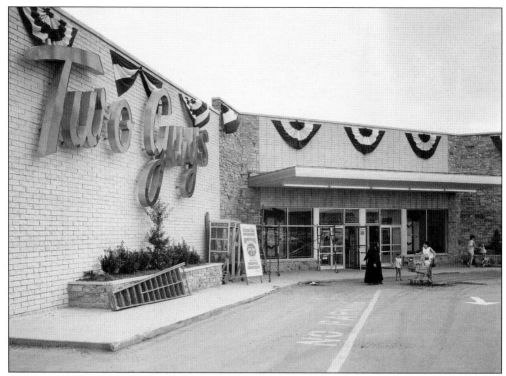

TWO GUYS ON ROUTE 18. The opening of Two Guys on Route 18 in 1957 was a milestone for East Brunswick. This was the township's first major department store. They had all types of products under one roof, similar to the Walmart of today. The Route 18 store shut down in 1981 after the company filed for bankruptcy.

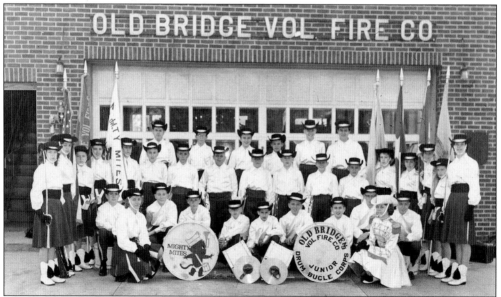

OLD BRIDGE VOLUNTEER FIRE COMPANY DRUM AND BUGLE CORPS. Members of the Old Bridge Volunteer Fire Company's Drum and Bugle Corps are pictured outside of the fire station on Pine Street.

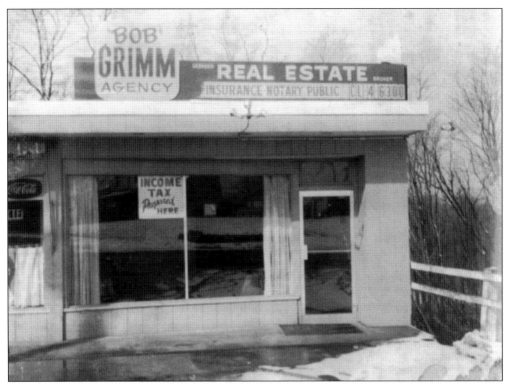

BOB GRIMM AGENCY, C. 1960. This is the office of the Bob Grimm Agency, a real estate firm, on Ryders Lane. The Knothole Confectionary convenience store is partially visible at left. This is currently the site of Vinnie's Pizza. (Richard Grimm.)

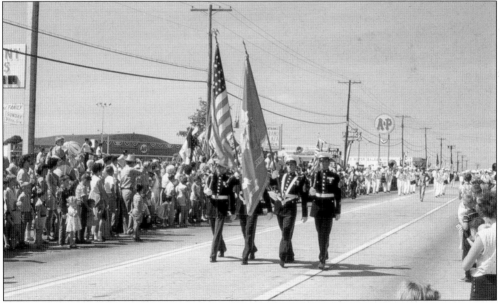

EAST BRUNSWICK CENTENNIAL CELEBRATION, SEPTEMBER 1960. East Brunswick Township was officially formed in 1860. In 1960, celebrations of the centennial of the township took place, including a parade down Route 18. (Ron Frankosky.)

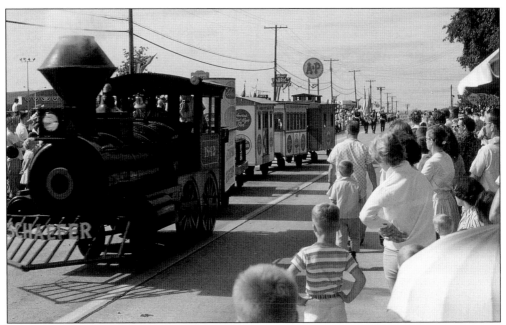

EAST BRUNSWICK CENTENNIAL PARADE. The 1960 centennial parade along Route 18 featured a number of floats and sponsors. This photograph shows one of the floats that was made to look like a steam train. The engine advertises Schaefer Beer. (Ron Frankosky.)

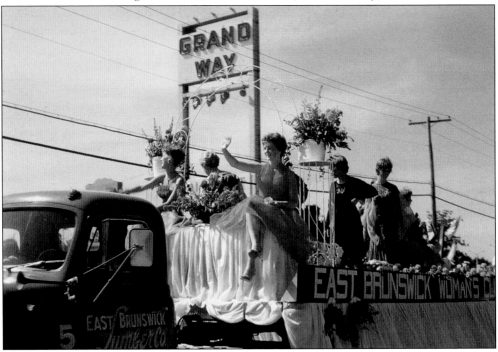

EAST BRUNSWICK CENTENNIAL CELEBRATION, 1960. The East Brunswick Women's Club float sits on the back of a truck from Route 18 Lumber. The club formed in 1952 with a mission to promote civic, educational, and social activities within the township and neighboring communities. (Ron Frankosky.)

OLD BRIDGE VOLUNTEER FIRE DEPARTMENT GROUNDBREAKING CEREMONY, MARCH 1961. The Old Bridge Volunteer Fire Department formed in 1906. In the late 1920s, a brick firehouse was built on Pine Street. By the early 1960s, the fire department had grown and needed additional space. This groundbreaking ceremony celebrated the expansion of the fire house. Both the 1920s firehouse and the 1960s expansion still stand on Pine Street.

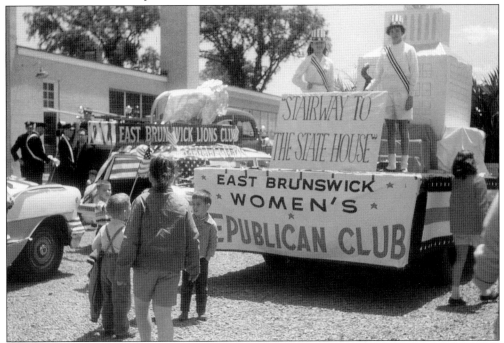

MEMORIAL DAY PARADE FLOAT, MAY 1961. The Memorial Day parade was once an annual tradition for the township. Here, one of the floats is being set up outside Central School. (Don Sauvigne.)

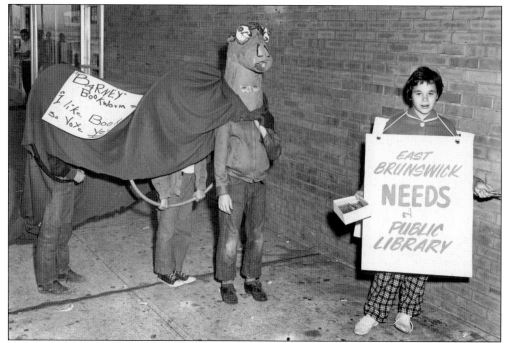

East Brunswick Library Referendum, October 1961. The idea to establish a public library came up during a meeting of the Kiwanis Club in 1957. In 1961, the public library referendum came up for a vote but did not pass. It took two more tries until it passed by a slim margin in 1965. These children were trying to promote the referendum in 1961. (Ron Frankosky.)

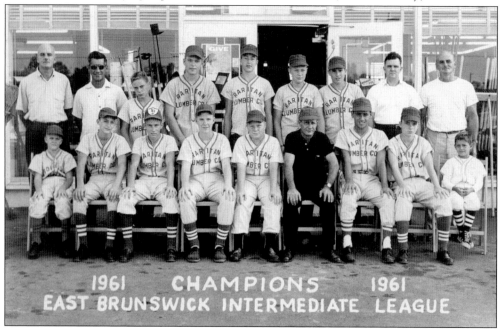

Raritan Lumber Baseball Team, c. 1961. Local business-sponsored sports teams became more prominent in the community around the mid-20th century. This is the baseball team that was sponsored by Raritan Lumber Company on Route 18 in the 1960s. (Bob Bennett.)

DUNHAM'S CORNER ROAD, C. 1962. This picture was taken in the vicinity of where Heavenly Farms is now located. Much of the idyllic setting can still be seen in this section of the township. (Craig Zavetz.)

RYDERS LANE, 1960s. This photograph of Ryders Lane was taken just north of the intersection with Milltown Road. Today, the Home Depot shopping center is located to the left of the road. (Bob Bennett.)

St. Barthomolew's Church. St. Bartholomew's parish was formed in 1959, and by 1962, the church (to the left of the image) had been built along Ryders Lane. The school, which is visible in the center of the image, was constructed in 1964. Today, the parish consists of over 4,000 families.

Country Lane Park Baseball, c. 1962. This picture was taken at an East Brunswick Managers Farm System baseball game at Country Lane Park. (Virginia Brewster.)

EAST BRUNSWICK JEWISH CENTER. In 1958, the East Brunswick Jewish Community Group was formed to meet the religious needs of the Jewish people moving to East Brunswick from the New York City area. Originally headquartered in Grange Hall, by 1961, the group had bought a plot of land to erect their own building on Ryders Lane, which they still occupy today.

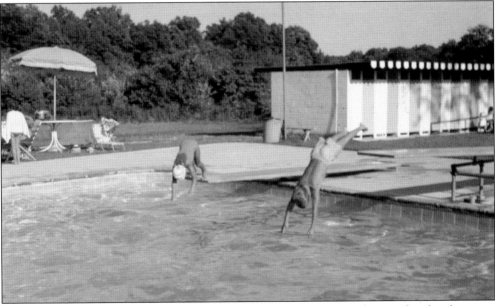

COUNTRY SWIM CLUB, C. 1962. Private swim clubs became appealing to families living in suburban communities during the mid-20th century. The Country Swim Club on Dutch Road was East Brunswick's first member-owned private swim club. At that time, it was the first in-ground swimming pool available for residents who could afford to join the club. These unidentified children are happily taking a dive into the pool. (Susan Kramer.)

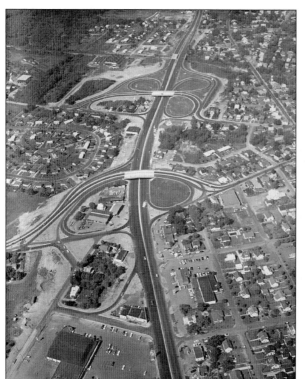

CRANBURY AND MILLTOWN ROAD OVERPASSES ON ROUTE 18, C. 1964. The Cranbury–South River Road developed in the early 1800s as a transportation route to connect farmers in Cranbury to the docks in South River. One of the prime products shipped during this period was peaches bound for steamboats at South River. Route 18 bisected the road in the 1920s, and as the highway grew in the 1960s, an overpass was constructed that eliminated the intersection of the two roads.

ARTHUR STREET RIBBON-CUTTING CEREMONY, OCTOBER 1964. Township committeeman Aleck Borman (right) is shown cutting the ribbon for Arthur Street, which connected Summerhill Road and Route 18. Standing beside him are (left to right) Arthur Taub, Chester Daskiewicz, and David Germain. (Aleck Borman family.)

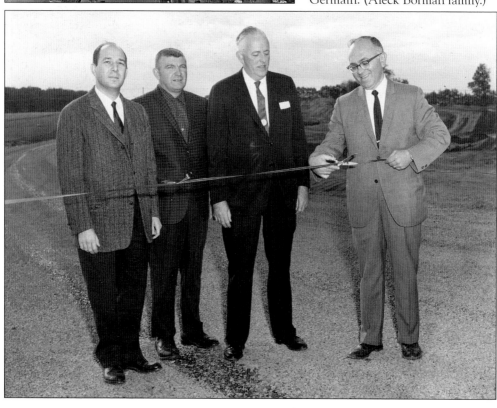

MAYOR AND COUNCIL MEMBERS, 1965. In 1965, Aleck Borman (seated) became East Brunswick's first elected mayor under the new mayor-council government, replacing the township committee that had been in existence since 1860. Behind Borman are Democratic council members (left to right) John Howe, John Rooney, James Bornheimer, and David Foley. (Aleck Borman family.)

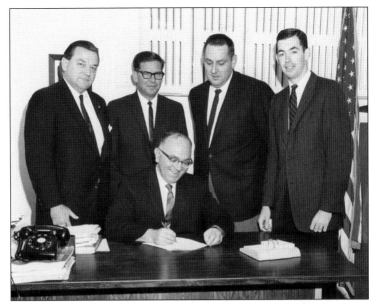

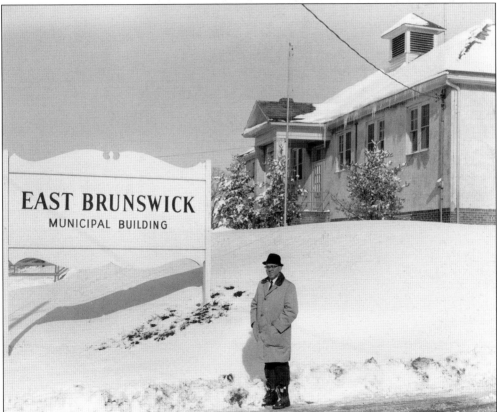

EAST BRUNSWICK MUNICIPAL BUILDING ON ROUTE 18, C. 1965. Before the township had its own municipal building, the committee would rent out other facilities for use as municipal headquarters. Mayor Aleck Borman is pictured outside one of these facilities—the former Weston's Mill School building on Route 18. (Aleck Borman family.)

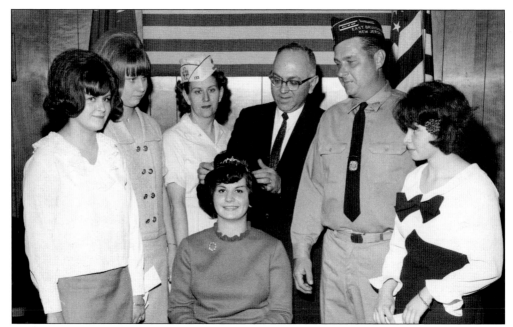

VFW's Miss Poppy Queen Crowning, April 1965. Mayor Aleck Borman is shown crowning Barbara Murray as 1965's Miss Poppy Queen at the VFW Hall. (Aleck Borman family.)

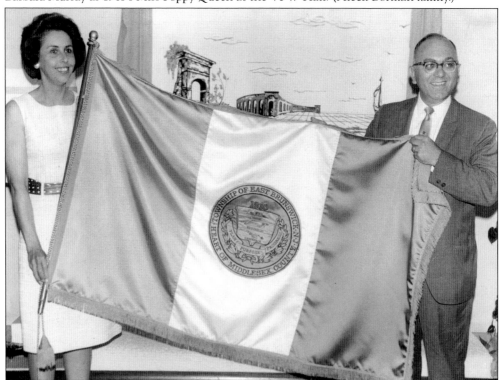

Township Seal Presentation, July 1965. Mayor Aleck Borman and East Brunswick Woman's Club president Gloria Meyer display the new township seal. Designed by Leon Tadrick, the seal is still used by the township to this day. (Aleck Borman family.)

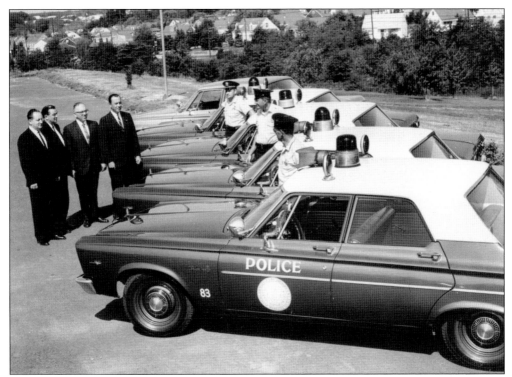

EAST BRUNSWICK POLICE CARS, JULY 1965. Five new patrol cars are shown lined up in the East Brunswick High School parking lot for inspection by township officials. (Aleck Borman family.)

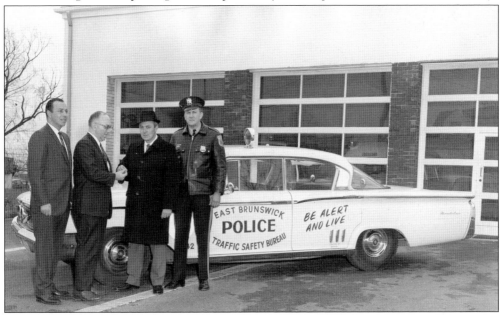

EAST BRUNSWICK POLICE TRAFFIC SAFETY BUREAU CAR, DECEMBER 1965. Ray French (second to the right) is pictured handing Mayor Aleck Borman the keys to the Traffic Safety Bureau vehicle that French donated to the newly established organization. Safety director Daniel Spisso (left) and patrolman Stephen Thomore (right) stand next to French and Borman. (Aleck Borman family.)

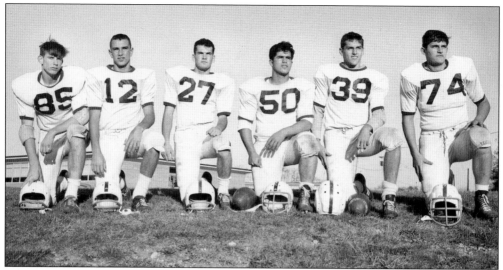

EAST BRUNSWICK HIGH SCHOOL FOOTBALL PLAYERS, C. 1965. Sports did not play a major role in the community until the opening of the high school in 1958. The Bears' team name has since become synonymous with the township. These are some of the high school varsity football players from the 1965 season. Second from left is David Wohl, who would later go on to coach the New York Nets. (John Emery.)

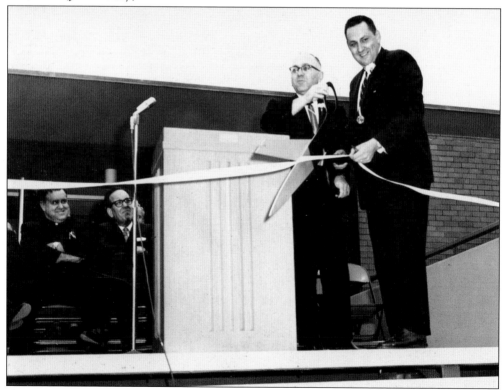

MUNICIPAL COMPLEX DEDICATION, MAY 1967. Mayor Aleck Borman and councilman James Bornheimer are shown cutting the ribbon for the dedication of the municipal complex on Ryders Lane.

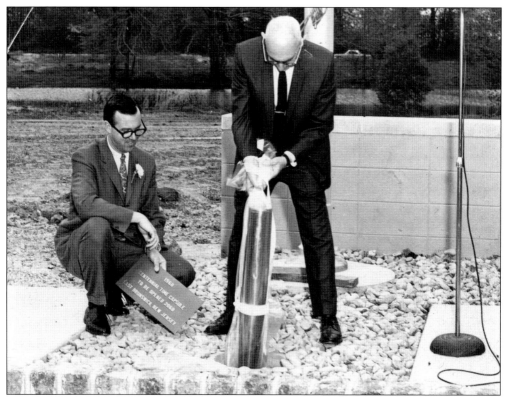

MUNICIPAL COMPLEX DEDICATION TIME CAPSULE, MAY 1967. Mayor Aleck Borman placed the centennial time capsule during the dedication of the municipal complex. The capsule was put together for the township's centennial in 1960 and was slated to be buried when the municipal building was established. The capsule is set to be opened in 2060.

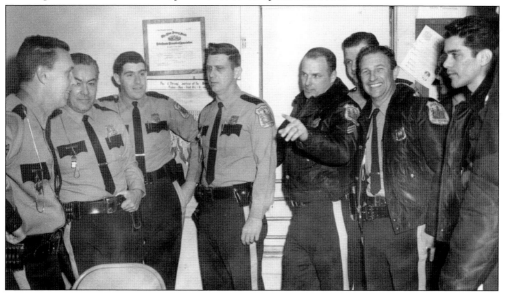

EAST BRUNSWICK POLICE OFFICERS, LATE 1960s. These township police officers are pictured inside their Wallace Street headquarters. (Jim Selnow.)

Wyndmoor Apartments, January 1969. When the township constructed the municipal complex, part of the plan was to add residential units. These are the Wyndmoor Apartments, which surround the municipalities of the complex.

East Brunswick Vocational School, December 1969. The East Brunswick Vocational School opened in 1970 and was the fourth such school built in Middlesex County. The school cost $6.7 million to build and was located on a 60-acre tract on Rues Lane.

Six

THE RECENT PAST

By 1970, East Brunswick's population had increased tenfold. By this time, nearly 35,000 residents were living in the township—a huge jump compared to 20 years earlier, when the count numbered around 5,000. No other community in the county had experienced such a significant increase in population.

At this point, the township had solidified its existence as a major suburban community in the heart of Middlesex County. A number of farms still remained in the community, but their numbers shrank as the years went on. While East Brunswick had been around for more than a century at this point, the township's greatest growth and change happened between 1950 and 1970.

As more developments were established, a lot of history was lost, and none more tragically than the Lilac House on Schoolhouse Lane. The 1700s-era house was slated for demolition by the New Jersey Turnpike Authority but ended up being set ablaze by possible arsonists, much to the disappointment of preservationists who wanted to save the home. The destruction of the Lilac House prompted the founding of the East Brunswick Historical Society in 1972, creating a resurgence in interest in local history. Much of that interest was focused on the village of Old Bridge, the oldest section in the township, which dates to the late 1600s. The Old Bridge Village Fair started in 1975. Two years later, this section of town was listed in the National Register of Historic Places. The following year, the East Brunswick Museum was founded, and the township's past is proudly displayed at the former Simpson Methodist Church building.

This period also brought the township's first—and, so far, only—female mayor, Jean Walling, who was elected during the height of the women's liberation movement. Her tenure was brief, as her life ended up being cut short by cancer. One of her final wishes was for the new East Brunswick Public Library building to come to fruition. The building opened to the public by 1976. By the 1980s, apartments and condominiums had started to take over what was left of the old farms along Cranbury Road. The township also faced a massive garbage crisis, as the closure of multiple dumps resulted in garbage trucks being rerouted to Edgeboro Landfill, which created heavy truck traffic on Route 18 and an enormous stench for those living nearby. Tower Center was also built around this time; it was not only the tallest structure in the township but also in the county.

TAMARACK GOLF COURSE, JUNE 1970. Tamarack Golf Course was established under the Middlesex County Board of Freeholders. It was East Brunswick's first professional golf course since the Lawrence Brook Country Club had shut down more than 20 years earlier. This course still continues to attract many enthusiasts of the sport.

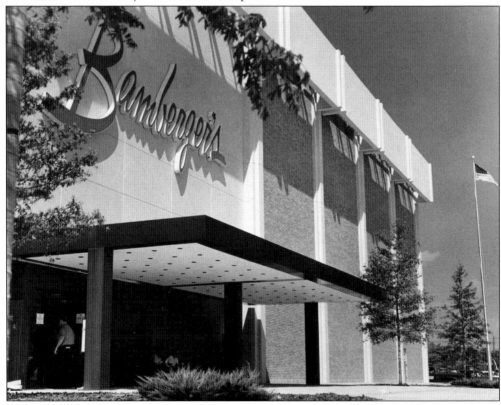

BAMBERGER'S STORE OPENING, SEPTEMBER 1970. Bamberger's originally opened as a stand-alone department store on the former site of the Ostroski farm on Rues Lane. Its opening drew more than 25,000 eager shoppers. Children got the chance to leave their handprints in cement. The rest of the mall was not completed for another three years.

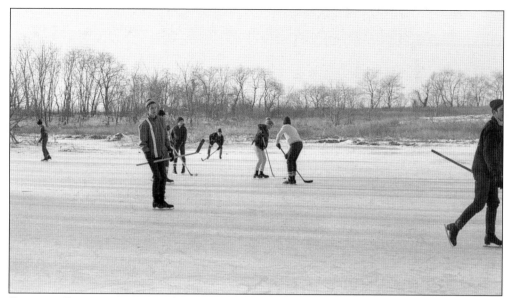

GARBOSKI FARM ICE HOCKEY. This pond on the Garboski farm in East Brunswick served as both a source of water for the farm fields and as a local ice-skating pond in the winter. This picture was taken on a cold day in 1971, and although the pond no longer exists, Great Oak Park and the Garboski homestead on Rues Lane survive. (Garboski Family.)

MIDDLESEX COUNTY CHILDREN'S SHELTER, FEBRUARY 1971. This brick structure off of Hardenburg Lane was originally constructed as a stable for the Connolly estate on Riva Avenue and Hardenburg Lane. After it was left abandoned for some time, Middlesex County took over the building and began to use it as a children's shelter for juveniles. Since 1975, the building has been used for Camp Daisy, which is now part of Bicentennial Park.

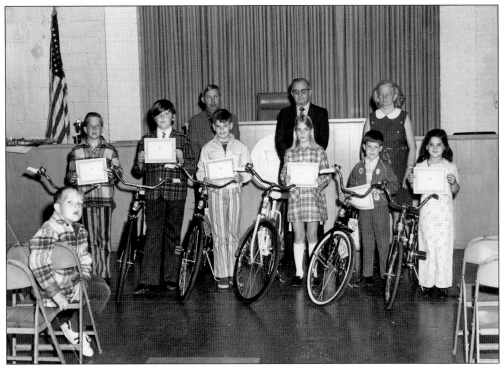

PBA Bicycle Safety Posters, April 1971. For several years, the Police Benevolent Association held a bicycle safety poster contest for kids. The prize was—fittingly enough—a bicycle. Pictured here are the winners of the 1971 contest.

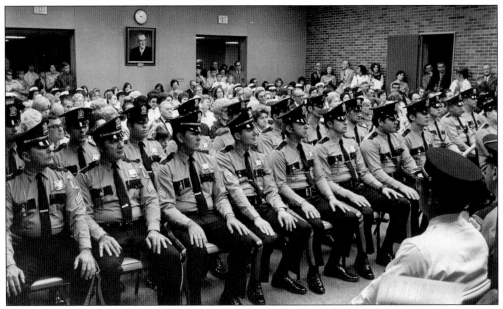

East Brunswick Police Department, June 1972. After the police department spent more than 30 years in a bungalow on Wallace Street, East Brunswick was able to build a $1 million police headquarters in the municipal complex. Several police officers are shown at the dedication of the new facility.

JAMESBURG PARK, FEBRUARY 1973. The idea to create Jamesburg Park was conceived during the early 20th century as a way to lure people to buy property at what they thought would become a development but was actually a scam. In the 1960s, as the rest of East Brunswick was being developed, a group of conservationists led by Rose Sakel sought to preserve this vast land, which they saw as an outlier to the Pine Barrens. Thanks to their work, nearly 1,500 acres are now preserved as a conservation area.

BRUNSWICK SQUARE MALL ENTRANCE, APRIL 1973. Brunswick Square Mall opened in 1973 as an extension of the Bamberger's department store that opened three years prior. The mall ushered in a new style of shopping, with many stores under one roof. The mall's location along Route 18, along with plenty of free parking, gave it a cutting edge over shopping in downtown areas. This photograph shows the mall's original entrance.

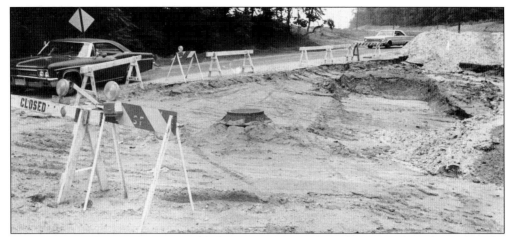

RIVER ROAD FLOODING, JULY 1973. The construction of new homes and roads needs to be balanced with its impact on the landscape. Water runoff can be problematic if it is not channeled correctly. The historic district saw much flooding and erosion along River Road when new homes were built farther up the street at the top of hill near Sunburst Drive. This image shows some of the damage from flooding in 1973.

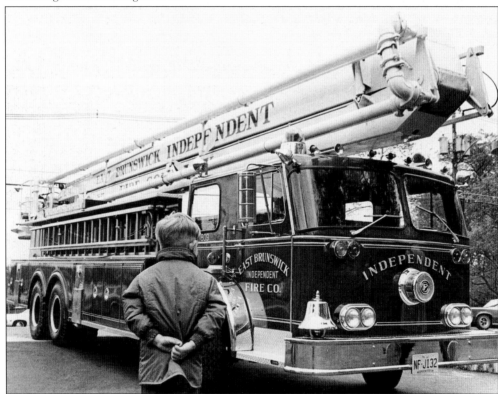

DUNHAM'S CORNER INDEPENDENT FIRE COMPANY HOUSE DEDICATION, MAY 1973. The first organized fire company in East Brunswick formed in 1906 in the Old Bridge section of the town. By the 1970s, several other companies had formed to meet the demanding growth of the township. Here, a child looks over the ladder truck of the newly opened Independent Fire Company house on Dunham's Corner Road.

POLICE PRESENCE ON HARDENBURG LANE AND RIVA AVENUE, MAY 1973. On May 3, 1973, East Brunswick was rocked by a major shoot-out that resulted in the death of state trooper Werner Foerster. While one of the suspects, Joanne Chesimard, was immediately arrested, one of the accomplices, Clark Squire, got away. This resulted in a 36-hour manhunt all over East Brunswick. Here, state troopers are on standby while a child waits for the bus.

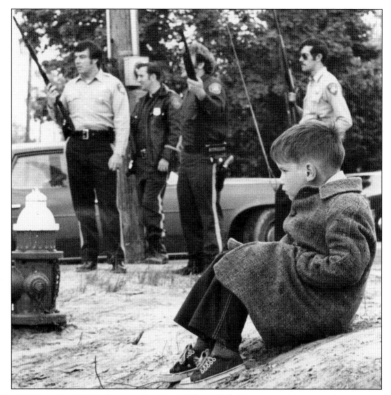

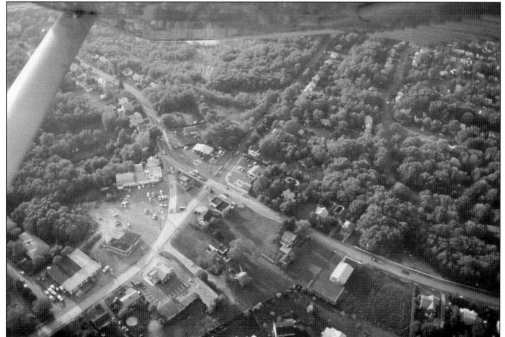

INTERSECTION OF RYDERS LANE AND MILLTOWN ROAD, 1973. This aerial photograph shows the intersection known as Herbert's Corner, which takes its name from the Herbert family that once lived in a home where the Wawa convenience store is now located. (Jerry Bergen.)

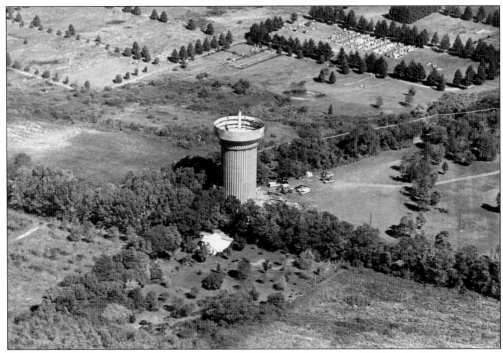

WATER TOWER CONSTRUCTION, OCTOBER 1973. New infrastructure had to be built to sustain the rapid growth of the township after the postwar years. The transportation of clean drinking water to newly constructed developments was made possible thanks to the construction of water towers. This tower near Fern Road was under construction when this photograph was taken.

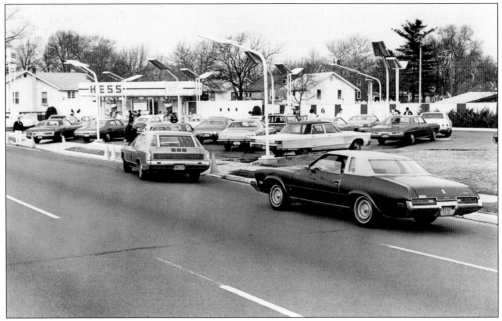

HESS GAS STATION, DECEMBER 1973. These cars are lined up along Route 18 at the Hess gas station. The oil crisis of 1973 was created by an embargo that started in October of that year. The shortage of gas supplies caused long lines at the pump.

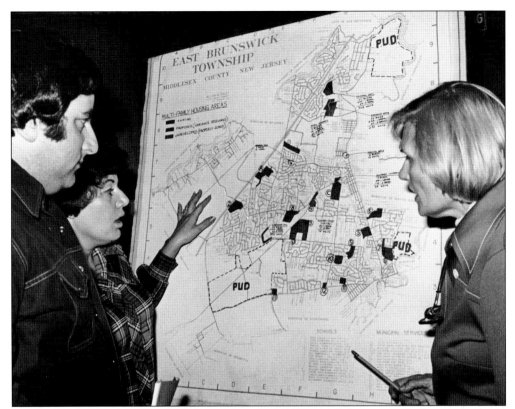

TOWNSHIP PLANNING, OCTOBER 1974. Mayor Jean Walling (right) is pictured talking to a couple of residents about the planning of high-density housing in the township. This became a hot topic for the township going into the 1970s and 1980s.

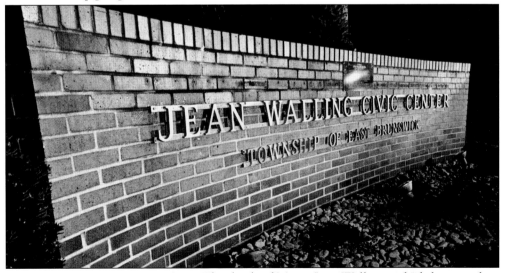

JEAN WALLING CIVIC CENTER SIGN. The death of Mayor Jean Walling rocked the township. Because she was the first (and, so far, only) female mayor in East Brunswick, the township wanted to honor her memory in a big way. On November 30, 1975, the Jean Walling Civic Center was named in her honor, and it still bears her name.

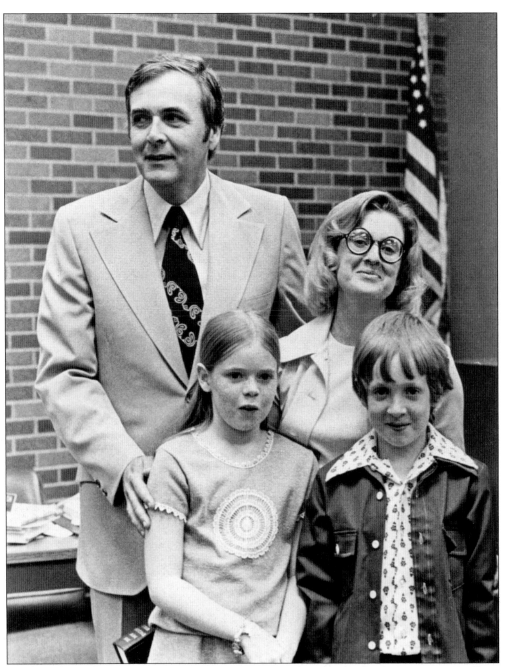

MAYOR WILLIAM FOX AND HIS FAMILY, MAY 1975. After the death of Mayor Jean Walling, someone immediately had to fill her position. That person was William Fox, whose prior experience included being the campaign manager for the 1974 Democratic council race and treasurer of the Democratic Municipal Committee for Middlesex County. Fox was expected to serve out the remainder of Walling's term until its expiration in 1976. What he did not anticipate was how long his tenure as mayor would last. He ended up becoming East Brunswick's longest-serving mayor and remained in the office from 1975 until the end of 1988. He is pictured with his then-wife, Mary Ann, and their two children, Kate and Bill Jr.

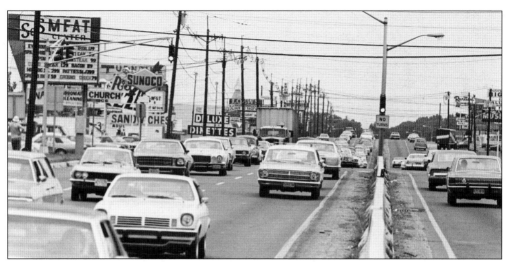

ROUTE 18 TRAFFIC, 1970s. This image was taken along Route 18 near Tices Lane.

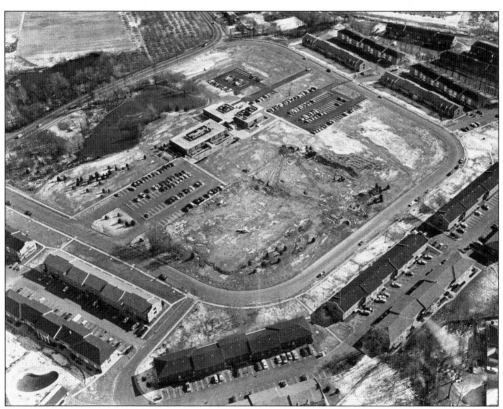

EAST BRUNSWICK PUBLIC LIBRARY CONSTRUCTION, 1975. East Brunswick's first public library opened in 1944 in a small historic home on Main Street in the township's historic district. The Alice Apple DeVoe Memorial Library served the community for decades, but by the 1970s, exponential growth warranted the construction of a larger and more modern facility. This image shows the East Brunswick Public Library under construction with the municipal building and police headquarters in the background.

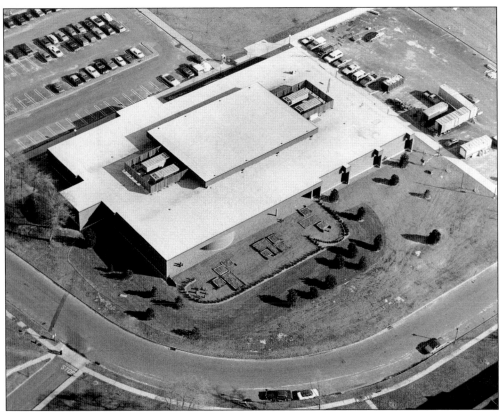

East Brunswick Public Library, 1976. The new public library opened on April 11, 1976, and became the area library for Middlesex County. This aerial photograph of the building was taken shortly after it was completed.

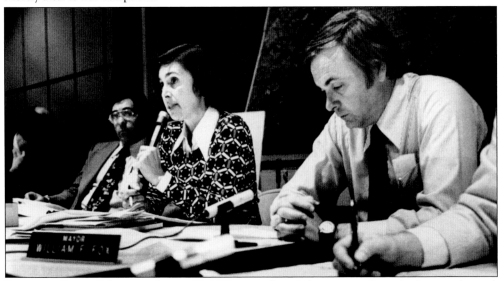

Planning Board Meeting, April 1976. Planning board chairwoman Joan Ambrowitz (center) is shown responding to a question from a resident during a planning board meeting at Frost Elementary School. Mayor William Fox is next to her to the right.

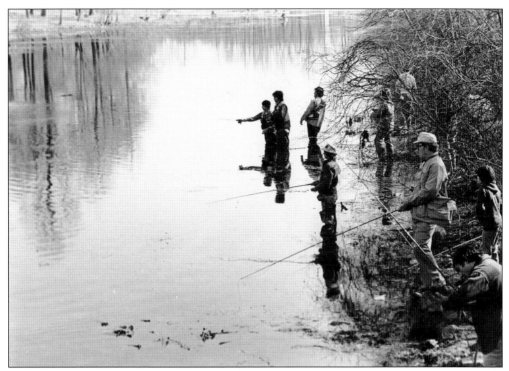

FARRINGTON LAKE FISHING, APRIL 1976. Farrington Lake has always been a popular destination for fishing. These unidentified fishermen are trying to catch a bite.

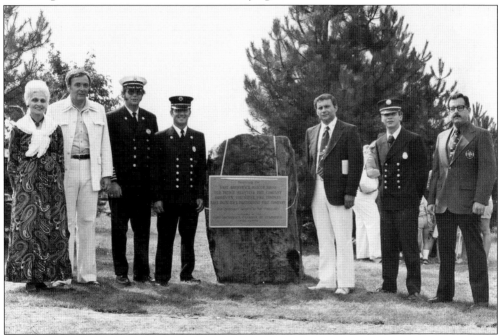

EAST BRUNSWICK CHAMBER OF COMMERCE PLAQUE PRESENTATION, JUNE 1976. Township officials, firefighters, and rescue squad members are shown in the municipal complex standing beside a plaque presented in honor of their hard work by the East Brunswick Chamber of Commerce.

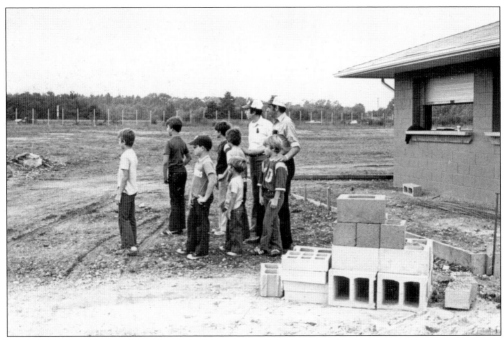

BASEBALL MANAGERS ASSOCIATION COMPLEX, C. 1976. These players and their coaches are looking out over the construction of the 10-acre East Brunswick Baseball Managers Association complex on Dunham's Corner Road. (Rosalie Littlefield.)

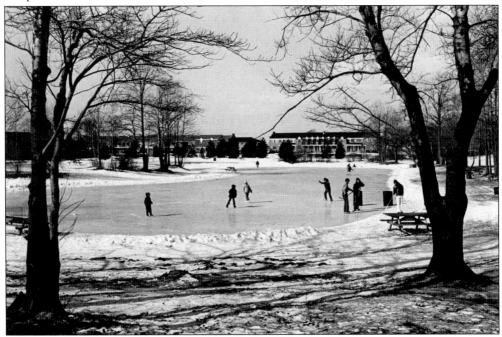

EAST BRUNSWICK MUNICIPAL POND SKATING, FEBRUARY 1977. When East Brunswick purchased Gatarz farm to build the municipal complex, the family requested that the township keep the pond. With that, the town was able to provide recreational ice-skating for its residents. The township provided this fun winter activity from the late 1960s until the mid-1980s.

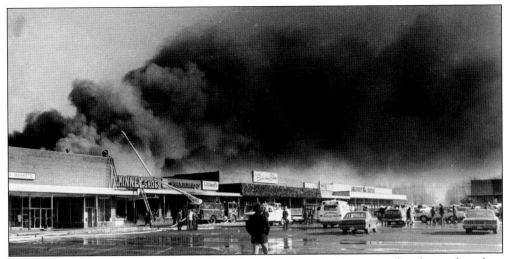

MID-STATE MALL FIRE, FEBRUARY 1977. No shopping center in the area endured more fires than the Mid-State Mall. In a nearly 20-year span, the mall suffered four major fires. The 1977 fire was not only the most damaging but also the most life-threatening. Three of the stores were completely destroyed. Reportedly, some of the Old Bridge volunteer firefighters escaped just seconds before part of the building caved in.

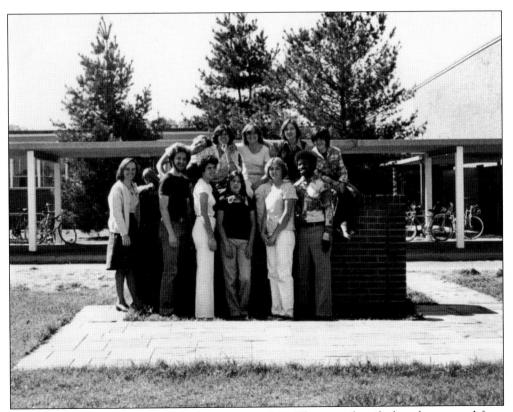

EAST BRUNSWICK HIGH SCHOOL STUDENTS, c. 1977. These unidentified students posed for a group picture outside East Brunswick High School. (John Emery.)

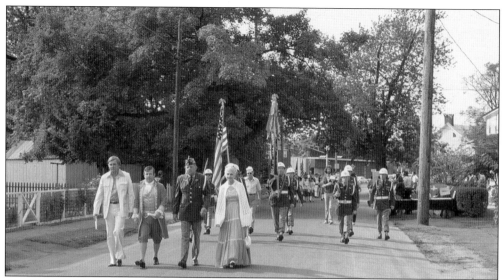

OLD BRIDGE VILLAGE FAIR, SEPTEMBER 1977. The 1970s became a period of renewed interest in US history fueled in part by the bicentennial celebrations of 1976. This appreciation for the country's history was also celebrated on a local level throughout Middlesex County. The Old Bridge Historic District, located in the southeast corner of East Brunswick, was Middlesex County's first historic district; it was listed in the state and national registers of historic places in 1975 and 1977, respectively. For many years, residents held a local street fair that included reenactors, parades, and antique dealers. This image shows a parade on Kossman Street near the intersection with Old Bridge Turnpike. Grace Auer is on the far right, and Mayor William Fox is on the far left.

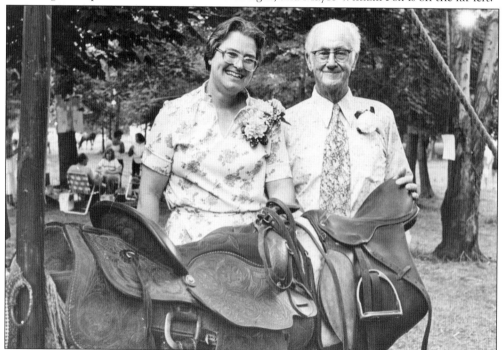

LOIS AND RUSSEL HERBERT, JULY 1978. Russel Herbert was one of the founders of the Middlesex County Fair and is responsible for its present-day success. He is pictured with his daughter, Lois.

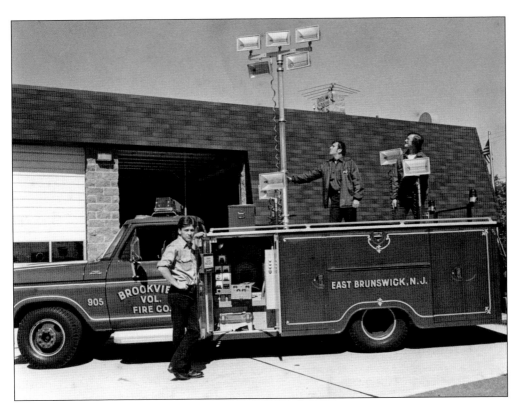

BROOKVIEW FIRE DEPARTMENT, OCTOBER 1978. From left to right, members of the Brookview Fire Company—Vic Romatowski, Jim Horner, and Cliff Williams—are showing off their $17,000 engine at their newly built firehouse on Dunham's Corner Road.

DR. JOSEPH SWEENEY, NOVEMBER 1979. Dr. Sweeney, through his leadership as superintendent of East Brunswick Public Schools from 1975 to 1989, helped make the school district one of the best in the state. His passion for the arts resulted in the high school auditorium being named in his honor. He was also not afraid to show his humorous side. He is shown dressed up as a town crier—an outfit he wore as he rode through the Sunburst Hills neighborhood to help promote a school bond referendum.

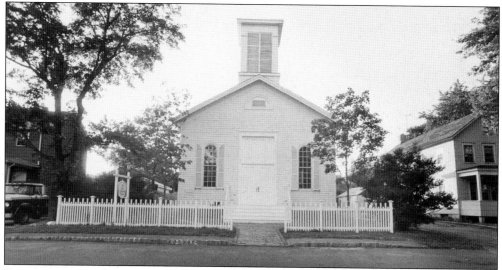

EAST BRUNSWICK MUSEUM, SEPTEMBER 1980. The East Brunswick Museum is housed in the former Simpson Methodist Church, which was built in 1862. This photograph was taken during the month when the museum officially opened to the public.

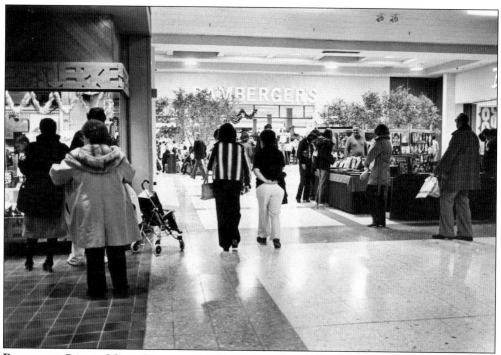

BRUNSWICK SQUARE MALL, DECEMBER 1980. Shopping has always been especially popular during the holidays, as shown in this image from the Brunswick Square Mall.

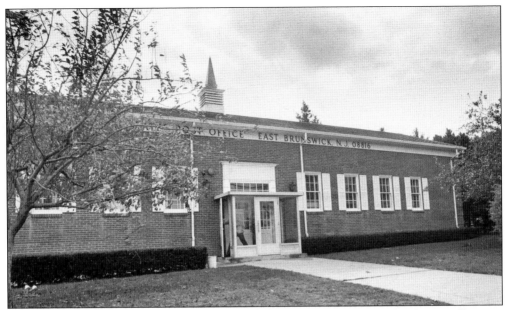

EAST BRUNSWICK POST OFFICE, OCTOBER 1981. During East Brunswick's development boom in the 1950s, the need for its own post office became apparent. Previously, residents used either Old Bridge, South River, or Milltown in their postal addresses. The first East Brunswick post office opened in the A&P Shopping Center on Route 18 in 1959. It was relocated to Grand Union Shopping Center in 1962. By 1966, it had settled into this brand-new building on Cranbury Road, where it remained until a more modern structure was built two miles down the road in 1992.

TRAIN TUNNEL UNDER THE OLD BRIDGE TURNPIKE. Clay was once mined from near the present-day location of Walmart on Route 18 in East Brunswick. This is why that location is one of the few places along Route 18 where the parking lot and store sit lower in the ground. The clay was shipped by rail to a brick factory on the other side of the Old Bridge Turnpike. A tunnel was built under the road to allow trains access from the clay pit to the factory. In 1982, the tunnel partially collapsed and was converted to carry stormwater runoff. This photograph was taken during the installation of the large water pipes.

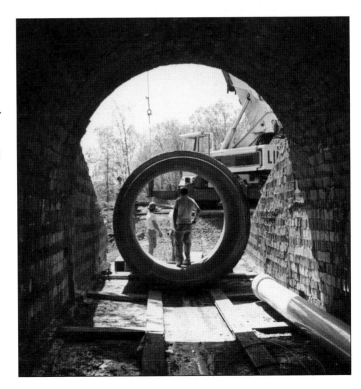

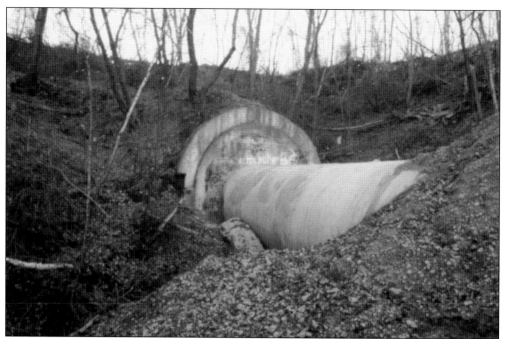

TRAIN TUNNEL UNDER THE OLD BRIDGE TURNPIKE, LATE 1980s. This image shows the old train tunnel after it was converted into a storm sewer. The concrete pipes and tunnel have since been covered and now lie underground near the parking deck. (Mark Nonestied.)

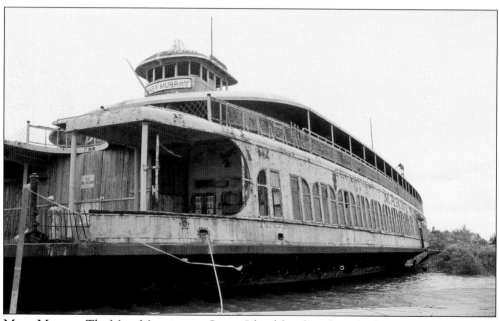

MARY MURRAY. The Mary Murray was a Staten Island ferryboat launched in 1937. The vessel was decommissioned in 1975 and purchased by George Searle. He moved it to his marina at the end of School House Lane in East Brunswick with intentions of creating a museum and restaurant. Those plans never materialized, and the dismantling of the vessel started in 2008.

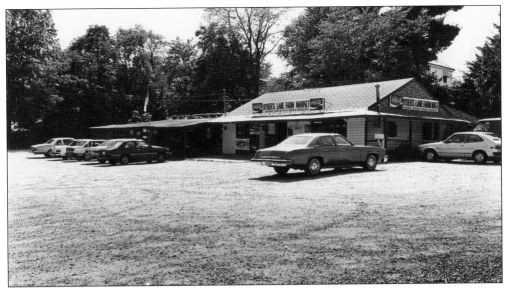

BROXMEYER'S FARM MARKET, SEPTEMBER 1983. Broxmeyer's Farm Market was a longtime staple for the community. Located on Ryders Lane, this beloved market provided fresh produce to residents for more than 50 years until it was closed in 2002. This site is now occupied by a Wendy's.

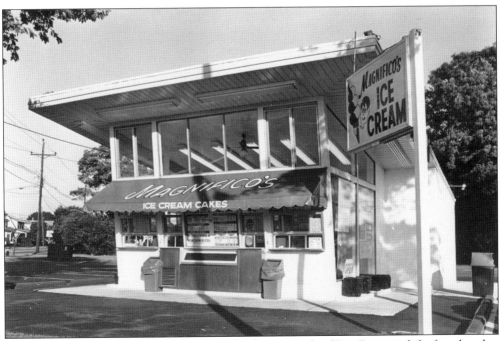

MAGNIFICO'S, SEPTEMBER 1983. Magnifico's has been a staple of East Brunswick for four decades. Formerly a Carvel, Magnifico's is best known for its soft-serve ice cream and Italian ices, and it draws big lines each summer.

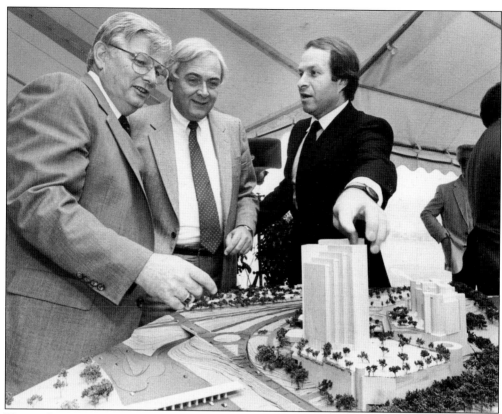

Tower Center Model, December 1984. Mayor William Fox (center) is pictured next to the model of the completed Tower Center complex on Route 18 during the center's groundbreaking ceremony. Developer Alan Landis (right) is pointing to the model, and looking on at left is Stanley Smith of AT&T.

Route 18 Flea Market, July 1986. The Route 18 Flea Market was located along Route 18 in East Brunswick. The flea market was a fixture for many years, with vendors selling a variety of goods. It was also home to Rock 'N' Roll Heaven, where the renowned band Metallica began rising to fame. The flea market building was torn down and replaced with a Walmart.

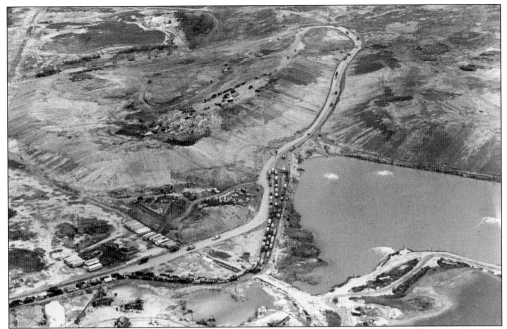

EDGEBORO LANDFILL AERIAL VIEW, APRIL 1987. Edgeboro Landfill has always been the subject of controversy. The landfill was offered as a replacement for the one on Harts Lane, which was causing a foul stench, after multiple residential developments were constructed nearby. During the 1980s, as multiple dumps were shutting down, all garbage trucks from outside the county were rerouted to Edgeboro, which created a garbage crisis for the township.

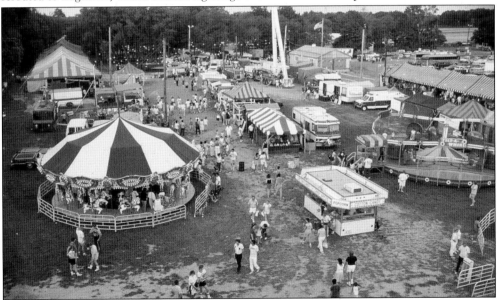

MIDDLESEX COUNTY FAIR, 1989. The Middlesex County Fair was started by the East Brunswick Grange in 1937 and began as a celebration of the agricultural contributions to the community. Today, it focuses more on entertainment, with rides and shows, but still displays its agricultural roots. It was originally held on Dunham's Corner Road, but since 1965, it has been held at a much larger site on Cranbury Road.

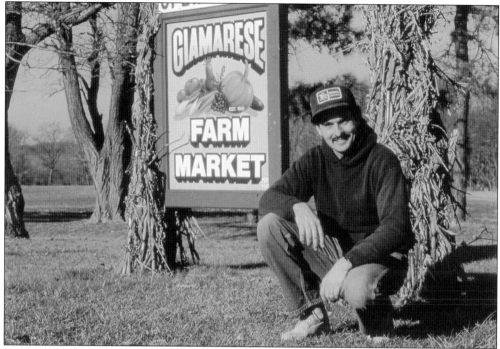

GIAMARESE FARM. Giamarese Farm is one of the few remaining active farms in East Brunswick. This family-run farm continues after 80 years of operation and is now under the management of Jim Giamarese. The farm is a popular destination for picking pumpkins, apples, and strawberries.

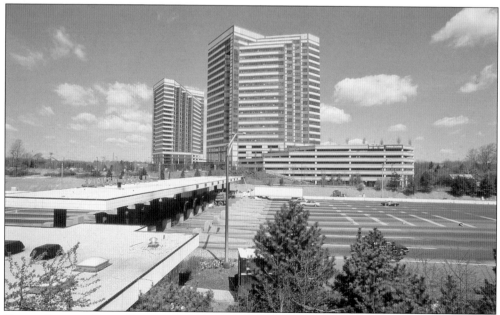

TOWER CENTER. Tower Center was built in the 1980s on the former site of the Ramada Inn on Route 18. The towers have become a symbol for modern-day East Brunswick. Its towering height of 279 feet can be seen for miles, even as far away as Manhattan.

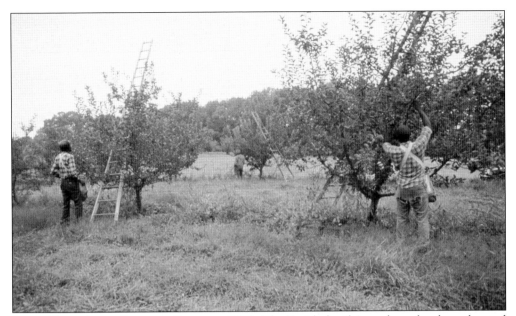

SMITH FARM APPLE-PICKING, OCTOBER 1991. The Smith family's apple orchard was located along Milltown Road. The orchard was one of the largest in New Jersey, with 4,500 trees and an annual yield of 35,000 bushels. The orchard was removed in the late 1990s, and today, the Apple Ridge Estates—with streets appropriately named for different apple varieties—occupy the site. The Smith farmhouse still stands and is now the home of the East Brunswick Historical Society.

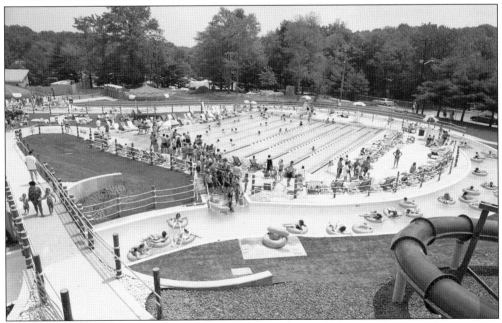

CRYSTAL SPRINGS FAMILY AQUATIC CENTER OPENING. After declining membership and a loss of revenue for the township, it was decided to convert the community beach into a blue-water aquatic center. On July 4, 1994, Crystal Springs Family Aquatic Center officially opened to the public. This was a huge deal not just for East Brunswick but for the state in general, as it became New Jersey's first municipal-run water park. This is a view of the park on its opening day.

RESCUE SQUAD FIRE AFTERMATH, MARCH 1999. The destruction of the rescue squad building on Prigmore Street was a major loss for the township. Three of its vehicles were destroyed along with years of archival papers. The squad eventually relocated to the former post office building on Cranbury Road.

KOSSMAN STREET, ALBERTA YUHAS. Alberta Yuhas and her husband, John, lived in this home on Kossman Street in the township's historic district. The house was built in 1871 and initially occupied by Henrietta Disbrow, a local dressmaker. Alberta was a monumental figure in the community and actively involved in the East Brunswick Museum. She passed away in 2010 at the age of 87.

Seven

PAST AND PRESENT

East Brunswick has seen much change. Much of this change is documented through photographs, many of which can be found in this book. A photograph documents its subject matter and freezes it at a particular point in time. One can look at old photographs of a certain area and immediately recognize the change that has taken place. Sometimes, one can compare historic images with later images of the same location and compare and contrast them to see how the area has developed.

This chapter focuses on pictures of locations taken at different times and offers a glimpse at the changes that have occurred between the past and the present.

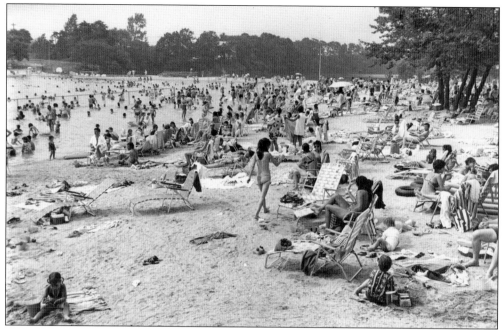

DALLENBACH COMMUNITY BEACH, JULY 1973. The soils of East Brunswick were not only utilized for growing crops; local deposits of clay and sand were also mined and sold for various purposes. Dallenbach was one of several sand companies in East Brunswick. The borrow pits that were created from excavations often became popular swimming holes, as shown in this image.

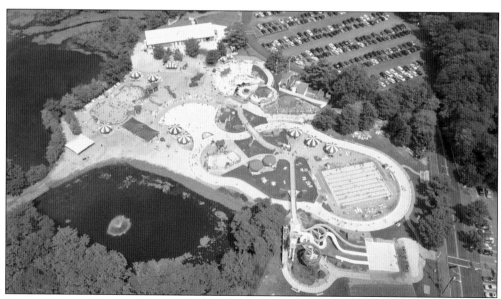

AERIAL VIEW OF CRYSTAL SPRINGS FAMILY WATERPARK. Today, Crystal Springs Family Waterpark draws thousands each summer. The former community beach lake now has a fountain spring put in place, and swimming in any of the lakes above has since been prohibited. (Ethan Reiss.)

AERIAL VIEW OF RUES LANE AND ROUTE 18, C. 1957. Even as East Brunswick started to become more developed in the latter part of the 1950s, there was still an abundance of farmland. This image shows the rural setting of Rues Lane and Route 18 around that time.

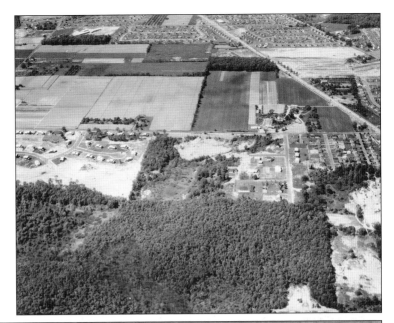

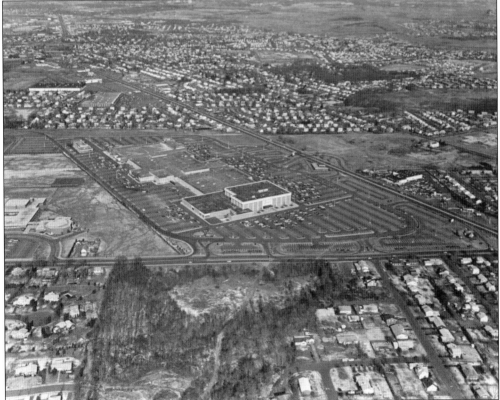

AERIAL VIEW OF RUES LANE AND ROUTE 18, 1970s. By the 1970s, shopping malls, residential neighborhoods, and larger schools had practically taken over the farms in East Brunswick. The Brunswick Square Mall and the vocational school, both visible here, were built on the former site of the Ostroski farm.

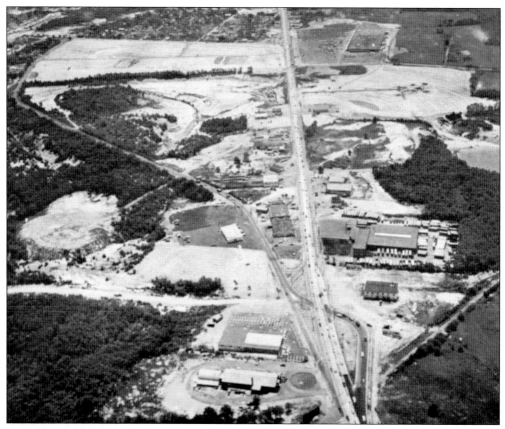

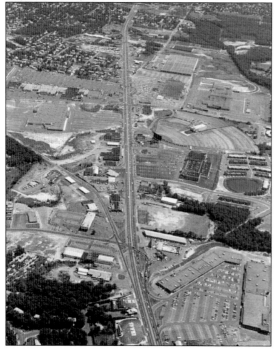

AERIAL VIEWS OF ROUTE 18 AND OLD BRIDGE TURNPIKE, C. 1957 (ABOVE) AND AUGUST 1974 (LEFT). These photographs, taken approximately two decades apart, show the Old Bridge Turnpike as it merges into Route 18 North near Edgeboro Road.

GARBOSKI FARM, C. 1972. The lone tree in the center of the Garboski farms sticks out like a sore thumb in this image. When the land was cleared for the farm around 1910, the tree was so large that it was impossible to cut down. (Garboski family.)

GREAT OAK PARK. Today, this tree, which is more than 200 years old, serves as the centerpiece for Great Oak Park. Located on Rues Lane, the park is a favorite destination for families and many of those who live in East Brunswick.

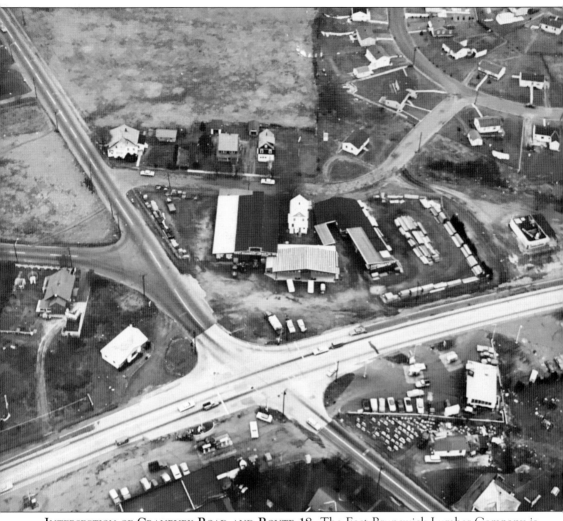

INTERSECTION OF CRANBURY ROAD AND ROUTE 18. The East Brunswick Lumber Company is visible near the center of the intersection. (Louis and Joy Goldstein.)

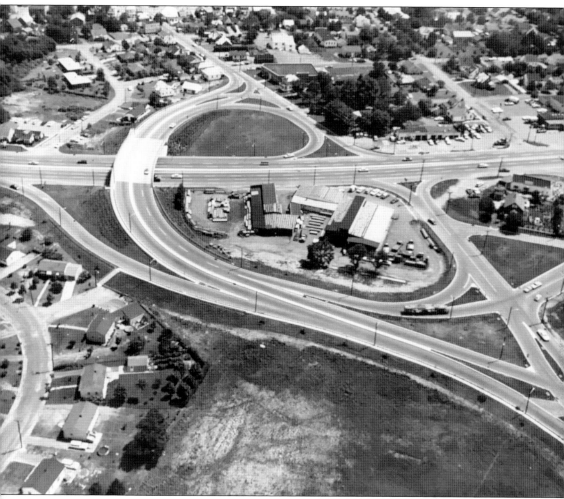

AERIAL VIEW OF CRANBURY ROAD AND ROUTE 18 OVERPASS, C. MID-1960S. This image features the same intersection shown on the previous page but with a newly completed overpass that was constructed in 1964. With the expansion of East Brunswick in the postwar years, more and more traffic contributed to road congestion—which remains an ongoing issue. The construction of this overpass alleviated traffic jams along two major roads. (Louis and Joy Goldstein.)

RAMADA INN HOTEL. The Ramada Inn off of exit 9 near the New Jersey Turnpike was built in the early 1960s as the Brunswick Inn. Not only was it the first motel built in East Brunswick, but it was also touted as one of the largest in the state at that time. This motel hosted presidential candidates and hopefuls, including Eugene McCarthy and Jimmy Carter.

RAMADA RENAISSANCE HOTEL. The Ramada Inn hotel was demolished in 1984 to make way for a fancier luxury hotel built between the towers of the Tower Center Complex. It is sometimes used for New Jersey gubernatorial election night parties.

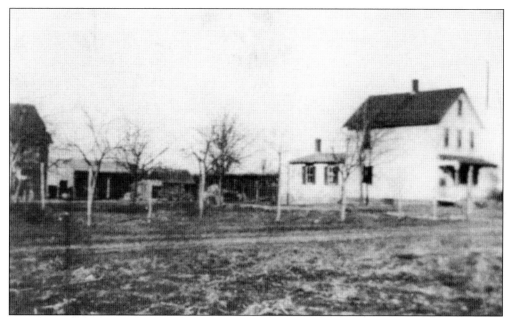

Zieminski Farmhouse, c. 1918. The Zieminski farmstead included both the family home and several outbuildings, such as the large barn to the left of what is shown here. (Zieminski family.)

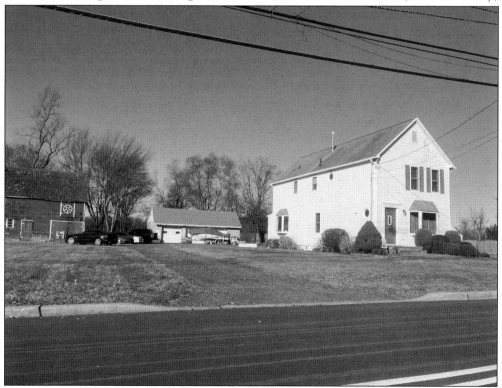

Zieminski Farmhouse Today. Although the original building has been modified over the years, the Zieminski farmhouse still stands at 166 Rues Lane. The outbuildings in the earlier image also still survive. (Photograph by Mark Nonestied.)

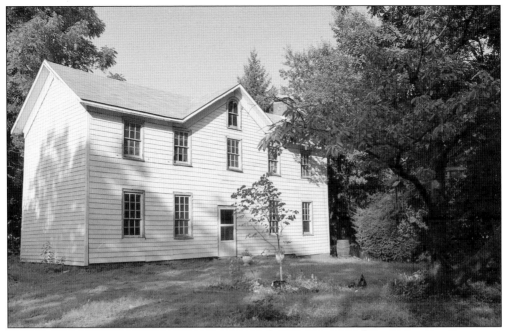

ROGERS HOUSE, 1997. The Rogers House at 26 Maple Street is pictured just prior to its restoration. Daniel Ricketts and his wife built the home around 1827. William Rogers and his wife, Adeline, purchased the home in 1838 and expanded the building. Members of the Rogers family continued to live in the home for over 100 years. (Mark Nonestied.)

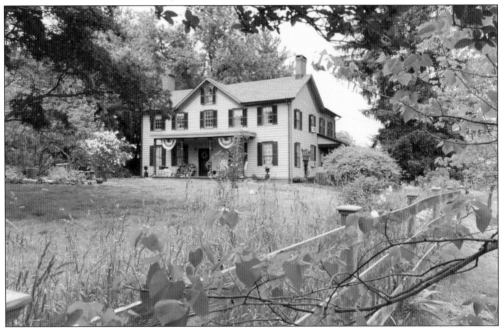

ROGERS HOUSE TODAY. William Rogers expanded this home in the mid-19th century, adding a kitchen wing. This section was apparently made up of an earlier structure that was salvaged or moved to the property, as some of the original timbers are rough-hewn logs. In the late 1990s, the house was restored to its mid-19th-century appearance. (Mark Nonestied.)

FIRST MAYOR OF EAST BRUNSWICK TOWNSHIP. East Brunswick Township was formed on February 28, 1860. Leonard Appleby was the first mayor and served from 1860 to 1862. He was born on October 4, 1798, and became an active businessman involved in the trades of wood, lime, and pottery, and he later engaged in the snuff and tobacco trade. In 1821, he married Ann Amanda Fitzallen Van Wickle, and they eventually had 11 children. He died in Spotswood at the age of 82 on March 17, 1879.

MAYOR JEAN WALLING. Jean Sears Walling was born and raised in Troy, New York. After earning both a bachelor's and a master's degree at the State University of New York in Albany, she joined the women's reserve of the Navy, in which she served as a lieutenant from 1943 through 1946. She came to East Brunswick in 1957 and became mayor in 1972 after years of being involved with school affairs in the township. She married W. Donald Walling, and they had five children. Jean died at age 53 in 1975 after a courageous battle with cancer.

Eight

EAST BRUNSWICK TODAY

Today, East Brunswick remains the heart of Middlesex County. Now, with a population of nearly 50,000, East Brunswick continues to thrive in business, education, recreation, and the arts. However, the township also faces numerous challenges. The population has gotten older, and those 50 and over outnumber younger residents. This led to a dwindling school population during the 2010s, as the number of students in the graduating classes grew smaller each year.

That all changed with the COVID-19 pandemic, which led to many residents retiring sooner than expected, and a lot of them moved out of the township. With a new crop of young people taking their places, this is creating problems for the public schools. As the school-age population rises once again, the township's school-grade model cannot be sustained. As a result, for the first time in more than 35 years, the board of education will be restructuring the grade system for the 2022–2023 school year. Elementary schools will house students in kindergarten through fourth grade, Hammarskjold will house fifth and sixth graders, Churchill will return as a school for students in seventh through ninth grades, and the high school will remain a school for students in tenth through twelfth grades.

Route 18, once a center of commerce for Middlesex County, has been negatively impacted due to the rise in online shopping, leaving many vacancies along the heavily traveled highway. This worsened due to the fallout of the pandemic, which led to many businesses closing and more people working remotely from their homes. To keep up with the times, the township has devised a redevelopment plan that will take some of the vacant shopping centers and businesses and transform them into livable communities that mix business, education, recreation, and the arts. Work is already underway to redevelop the site of the former Hostess Factory into a new community that will include a community center and an ice-skating rink.

MAYOR BRAD COHEN. Dr. Brad Cohen was elected to the office of mayor in November 2016. Cohen began his public career in 2010, when he was elected to the East Brunswick Board of Education. He is a practicing gynecologist and is part of St. Peter's Physician Associates, with an office in East Brunswick. He has lived in East Brunswick for over 27 years with his wife, Penny, who is a dermatologist in Somerset. They have two children, Rachel and Daniel, who are graduates of the East Brunswick Public School system. Mayor Cohen has used his skills to improve the quality of life for the residents of East Brunswick.

EAST BRUNSWICK TOWNSHIP COUNCIL AND PUBLIC OFFICIALS. Photographed from left to right are state senator Patrick Diegnan, assemblyman Sterley Stanley, councilwoman Dana Zimbicki, councilwoman Sharon Sullivan, retiring councilman Mike Spadifino and his wife Kathy Spadifino, council president James Wendell, Mayor Brad Cohen, MD, councilman Kevin McEvoy, and councilman Dinesh Behal.

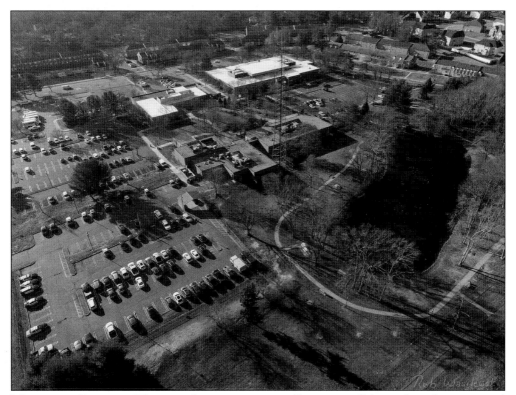

MUNICIPAL COMPLEX. The township government offices are still housed in the municipal complex on Ryders Lane after more than 50 years. Talks have arisen about potentially relocating some government and municipal services as the buildings continue to age. (Photograph by Robert Wasilewski.)

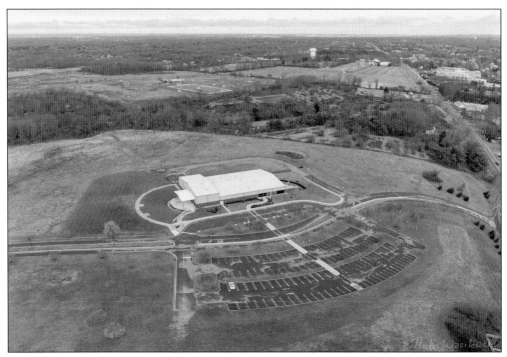

East Brunswick Community Arts Center. Until the 1950s, East Brunswick was viewed by some as a "cultural desert." Today, the arts are a valuable asset to the community. The East Brunswick Community Arts Center on Dunham's Corner Road is now home to Playhouse 22 and its productions. (Photograph by Robert Wasilewski.)

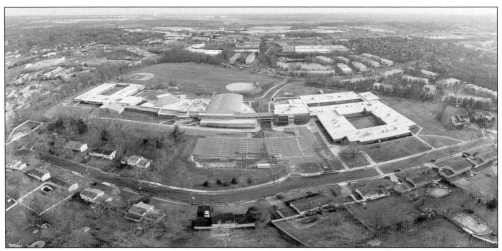

Churchill Junior High School. What were once state-of-the-art facilities have aged and can no longer accommodate the ever-increasing number of students. Churchill is among the local schools that have been expanded and modernized to suit the needs of students in the 21st century. (Photograph by Robert Wasilewski.)

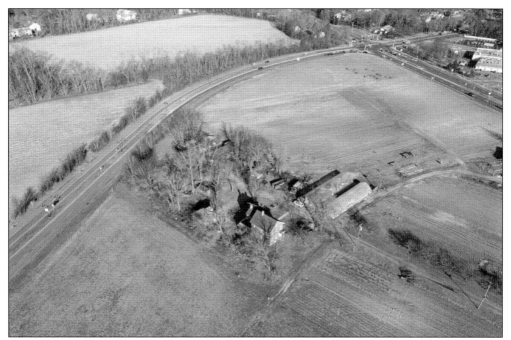

KELEMAN FARM. In the last few decades, efforts have been made to save the few farms left in East Brunswick. Keleman Farm is one of those that have been preserved under New Jersey's Open Preservation Act, which ensures that these lands will never be developed. (Photograph by Robert Wasilewski.)

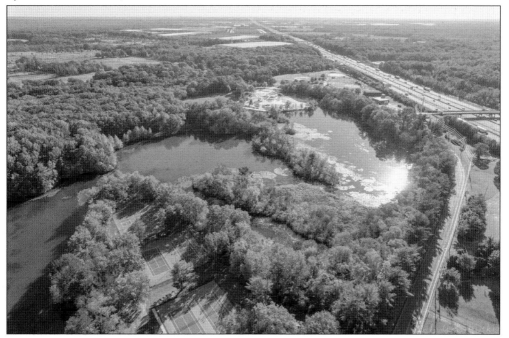

DALLENBACH SAND COMPANY LAKES. Nature parks and trails remain popular in East Brunswick. The former sandpits of Dallenbach Sand Company have formed into the lakes of today, and they serve as centerpieces for the East Brunswick Community Park. (Photograph by Robert Wasilewski.)

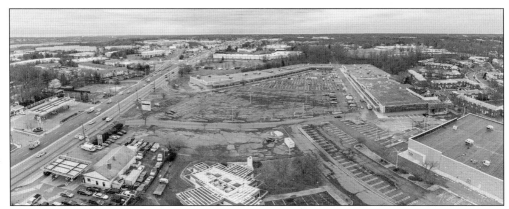

LOEHMANN'S PLAZA. Many of the shopping centers along Route 18 were constructed to suit the needs of the 20th-century shopper. Today, however, the internet has taken a toll on in-person retail. Shopping centers like Loehmann's Plaza had low vacancies in the age of online shopping. Plans to redevelop this area were underway at the time this book was published in 2022. (Photograph by Robert Wasilewski.)

TICES LANE REDEVELOPMENT. Pictured here is the site of the former Continental Baking Factory that produced Wonder Bread, among other products. The factory was recently demolished, and a new housing development is being built that will include a community center with an ice rink.

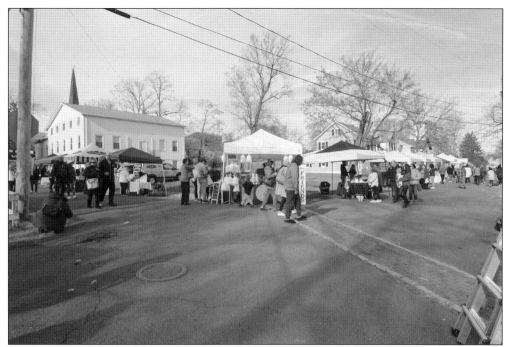

HARVEST FESTIVAL. In 2021, the Village Fair, once an annual tradition for the township, made a comeback after more than a decade as the Harvest Festival, now hosted by the East Brunswick Arts Coalition. (Photograph by Ethan Reiss.)

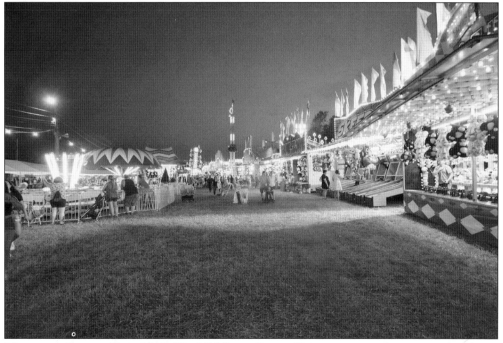

MIDDLESEX COUNTY FAIR, 2018. The Middlesex County Fair continues to be an annual tradition for the township after more than eight decades. In 2020, the fair had to be canceled due to the COVID-19 pandemic. However, the fair resumed the following year. (Photograph by Ethan Reiss.)

DISCOVER THOUSANDS OF LOCAL HISTORY BOOKS
FEATURING MILLIONS OF VINTAGE IMAGES

Arcadia Publishing, the leading local history publisher in the United States, is committed to making history accessible and meaningful through publishing books that celebrate and preserve the heritage of America's people and places.

Find more books like this at
www.arcadiapublishing.com

Search for your hometown history, your old stomping grounds, and even your favorite sports team.

Consistent with our mission to preserve history on a local level, this book was printed in South Carolina on American-made paper and manufactured entirely in the United States. Products carrying the accredited Forest Stewardship Council (FSC) label are printed on 100 percent FSC-certified paper.

MADE IN THE USA